HIDDEN HISTORY
of
Mississippi
BLUES

HIDDEN HISTORY
of
Mississippi
BLUES

ROGER STOLLE

Photographs by Lou Bopp

Charleston London

THE
History
PRESS

Published by The History Press
Charleston, SC 29403
www.historypress.net

First published 2011

Manufactured in the United States

ISBN 978.1.60949.219.9

Library of Congress Cataloging-in-Publication Data

Stolle, Roger.
Hidden history of Mississippi blues / Roger Stolle ; photography by Lou Bopp.
p. cm.
Includes bibliographical references and index.
ISBN 978-1-60949-219-9
1. Blues (Music)--Mississippi--Delta (Region)--History and criticism. 2. African Americans-
-Mississippi--Delta (Region)--Music--History and criticism. 3. African Americans--
Mississippi--Delta (Region)--Social life and customs. 4. Delta (Miss. : Region)--Social life
and customs. I. Bopp, Lou. II. Title.
ML3521.S76 2011
781.64309762--dc22
2011003670

CONTENTS

FOREWORD

By Jeff Konkel of Broke & Hungry Records

One evening in October 2005, I found myself knocking back a couple of beers at a down-home juke joint in rural Mississippi. The place was packed with a diverse crowd of locals and tourists united by their shared love for one of America's most important art forms: blues music.

Tucked into a back corner was Delta-born bluesman Big George Brock, blowing furiously into his harmonica. Throughout the juke, feet were tapping and heads were bobbing to the music. A few couples danced lasciviously.

It was the kind of night that blues lovers live for.

As the evening wore on, I struck up a conversation with a man sitting by the door with a stack of CDs. His name was Roger Stolle. Roger had moved to the Delta a few years earlier to open Cat Head Delta Blues & Folk Art, a store overflowing with blues CDs, records, books, magazines and art. In 2004, he had become one of the founders of the Juke Joint Festival, a major new music event in Clarksdale, Mississippi. And in the months prior to our meeting on that October evening, Roger had added music producer to his résumé. Frustrated by the failure of record labels to record Big George Brock, Roger took matters into his own hands and produced Big George's debut CD, *Club Caravan*, which would go on to garner worldwide praise.

I thought to myself: here's a guy who's putting his money where his mouth is.

When I returned to my home in St. Louis, I had a new sense of purpose. Inspired by Roger's example, I took immediate action. Within three weeks of our encounter, I formed Broke & Hungry Records, a label dedicated to recording and promoting traditional blues artists from Mississippi.

In the years since, Roger and I have spent a great deal of time together, hanging out in jukes, visiting musicians and collaborating on blues-related projects, like the award-winning movie *M For Mississippi*.

In the time that I've known Roger, I have never stopped marveling at the depth of his knowledge of and passion for blues. Over the past decade, no one has done more to promote and support Mississippi's rich blues heritage. His store has become a mecca for blues lovers, and he's made a major mark as a blues writer, radio host, music and film producer, artist manager, booking agent and more.

Readers of this book are in for a treat. You couldn't ask for a better guide to the past, present and future of Mississippi blues. Enjoy.

PREFACE

Elvis, Advertising and a State Called Mississippi

My Introduction to Blues

I grew up in a family that didn't really listen to much music. My dad loved talk radio, my mom had a few dusty albums we rarely played and my older sister mostly kept her pop records hidden from her less cool younger brother.

This all changed on the morning of August 17, 1977.

I was ten years old and living in Dayton, Ohio. As I walked into the family room of our small ranch home that morning, the local paper stared up at me from our faux-brick tile floor. Over the photo of a bejeweled Elvis Presley, a banner headline read, "The King is Dead at 42." Elvis's life, death, funeral and fans made the front page of the newspaper every day for the next week.

After all, as Presley's 1959 LP had proclaimed, *50,000,000 Elvis Fans Can't Be Wrong*. The public wanted all the gory details of the King's barbiturate, jelly-filled life and inglorious bathroom passing. The fans wanted more music, more movies, more Elvis. The newspapers, magazines, radio and television didn't disappoint.

I tell you all this to set the stage. After all, how on earth did a ten-year-old white kid in suburban Ohio find blues music and, twenty-five years later, move to Mississippi to be near it? In a word: Elvis.

Suddenly, his music was everywhere. My mom ordered the King's *Greatest Hits* LP off TV for me, and I began spending my paltry allowance on 45 rpm reissues of his earliest sides. I used a cheap cassette recorder my dad gave me to capture what songs I could from TV and radio, and slowly, I began to listen to the music more critically. I started to discern between

Elvis's Hollywood-meets-Vegas pop songs and his gospel, country and blues-influenced sides.

It wasn't long 'til I extracted the music that moved me from the stack of cassettes and vinyl. Elvis's versions of Mississippi-born classics like "That's All Right" (Arthur "Big Boy" Crudup of Forest, Mississippi) and "Mystery Train" (Herman "Little Junior" Parker of Clarksdale, Mississippi). There were Deep South–penned blues and R&B songs like "Good Rockin' Tonight," "Milkcow Blues Boogie" and "When It Rains It Really Pours." I moved first forward and then backward, listening to other artists, reading magazines and searching for what made this music so compelling and unforgettable.

I started paying attention to the song credits on the records, and every day, the picture came a little more into focus. This soulful, edgy music wasn't the product of my own white bread ancestry; it was the legacy of an African American art form that emanated from the south—far from my own midwestern comfort zone—deep in the land of catfish and cotton.

The music was blues. The state was Mississippi.

HOW I BECAME A WRITER

I've been a writer damn near all my life. Not a wordsmith. Not a poet. Just a writer.

When I was about knee high, I made primitive drawings on three by five cards, punctuated each with a brief line of text, stapled them all together and presented the crudely illustrated narratives to my relatives. I quickly realized that writing was much more my forte than drawing and, later, that it could also be my savior when confronted with my true arch nemesis—math.

Growing up, "books" mostly meant non-fiction to me. Having a somewhat obsessive personality, one hobby or collection would always lead to another: stamps, coins, beer cans, old newspapers, antique toy cars and even butterflies to name a few. I studied and collected them all (though only the tougher, more manly of the butterflies, of course). Unsurprisingly, field and collector guides often lit the way. *World Book Encyclopedias* were another personal favorite.

As I learned a bit about the world, I also learned how to put a couple words together.

Fast forward a decade or so. There I was, nearing high school graduation, finding myself sitting in a cramped, fluorescent-lit office with a disinterested

guidance counselor. When I mentioned that I either wanted to be a race car driver (cars: another hobby) or a lawyer (girls liked the sound of it), I was met with the kind of stare that makes you major in English literature. I added in journalism later, just for good measure.

Finally, after four years of Shakespeare, blue books and the school paper, I began answering every classified ad that began or ended with "writer." Soon, I was writing advertising copy for ladies' underwear and men's shoes. Soon, I was a professional writer.

GO WEST YOUNG MAN

After working my way up to senior copywriter some five years later, I was recruited for an advertising managerial position in St. Louis, Missouri. I moved, and six months later, my boss was fired. This began a rapid progression of promotions—first at that company, later at another.

In the end, I was the director of marketing, reporting directly to the president of a multibillion-dollar company. I traveled to New York, Chicago, Hong Kong, Taipei, Ljubljana, etc. on business. I had a team of fourteen

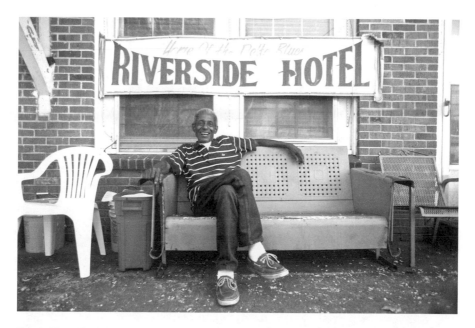

Frank "Rat" Ratliff sitting in front of his legendary Riverside Hotel (Clarksdale, Mississippi, 2009).

talented individuals reporting to me either directly or indirectly. I received raises, stock options and holiday bonuses. And we did super-cool, creative work, including brand creation, cutting-edge graphic design and even product development. On paper, I'd stumbled into the American Dream.

Then, I took a trip to Mississippi.

ACKNOWLEDGEMENTS

ROGER STOLLE

Special thanks to my wonderful parents and extended family for their love and support.

Thanks to The History Press (especially Will McKay) for commissioning this book.

Additional appreciation goes out to all of my blues friends and associates, including Kari Jones, Jeff Konkel (and his amazing family), Lou Bopp, Red Paden, Sarah Moore, Big George Brock, Bubba O'Keefe, Nan Hughes, Goldie Hirsberg, Damien Blaylock, Bill Abel, Sadie Mae Stolle, Bill Luckett, Bill Wax, Kappi Allen, Scott Barretta, Alex Thomas, Janet Webb, Rootsway Blues Association (especially Ferdinando, Andrea and Antonio), Sonny Payne, Jim Howe, Shonda Warner, Andria Lisle, Chip Eagle, Art Tipaldi, Ken Bays, Andrew Miller, Don Wilcock, Jim O'Neal, Michael Frank, William Ferris, Robert Mugge, Steve Cheseborough, Luther Brown, David Evans, La La, Cade Moore, Sean Appel, Joni Mayberry, Jennifer Stolle, Steve Ladd, Dick Waterman, Joe Baird, John Ruskey, Panny Mayfield, Catherine Clark, Yvonne Stanford, Bill Hayden, the Blues Foundation, LiveBluesWorld.com, Delta Music Experience, Mississippi Blues Marathon, KDHX (especially Jeff and Tony C.), WROX, KFFA, XM/Sirius, Juke Joint Festival, Clarksdale Film Festival, Clarksdale Caravan Music Festival, Sunflower River Blues Festival, King Biscuit Blues Festival, Highway 61 Blues Museum, Delta Blues Museum, Rock & Blues Museum, B.B. King Museum, Howlin' Wolf Museum, Delta Cultural Center, Delma Furniss Welcome Center, Hambone

Gallery, Delta Recording Service, Three Forks Music, Broke & Hungry Records, Mudpuppy Recordings, Fat Possum Records, Earwig Records, Rooster Blues, Delmark Records, Clarksdale-Coahoma County Tourism, Mississippi Blues Commission, *Blues Revue*, *King Biscuit Time*, *Blues & Rhythm*, *ABS Magazine*, *Delta Magazine*, *Living Blues*, *Big City Blues*, *Il Blues*, *Red Hot Rock* and all of my faithful Cat Head customers.

Finally, the greatest thanks of all goes to the blues players, past and present, who made this book possible, including all of those whose words appear within its pages.

Lou Bopp

Thanks to Roger Stolle, Jeff Konkel and Bill Abel (the one-man band); all of the musicians who appeared in front of my camera and put music in our ears; and my family, including the sweetest of them all, Joanna and Rose.

Red Paden in front of Red's Lounge juke joint (Clarksdale, Mississippi, 2010).

Introduction

A Blues Pilgrimage to the Mississippi Delta

A Juke Joint Changes Everything

The day was bright, hot and still. The latest meal of warm, mushy, fried food had me moving in slow motion. "Delta time," they called it. It was like running in water.

I'd been in Memphis for two days, done the museums and stood under the ancient sound tiles at Sun Studio. Beale Street had been a party but not the blues heaven I had long imagined. Now it was Sunday and time to pull out those crummy directions; the ones I'd hastily copied from a magazine or somewhere; the ones that led to a decaying old building near Holly Springs, Mississippi—to a juke called Junior's Place.

As I pulled up to what appeared to be an abandoned building built eons ago without the aid of an architect, some kind of little "deal" was going down out front. Once the coast was clear, I left the safety of the subcompact and took a leap of faith. Surely, one couldn't be killed here if the proprietor had records for sale in the malls of middle America.

It was so bright outside and dark inside that opening the thick plywood door and peering in did little to comfort me or answer the question, "Will there be music tonight?" As I waffled between going in and just-plain going, a voice called from the darkness. It was old, weathered and friendly. It said, "You can come on in." It was the man himself, David "Junior" Kimbrough. The same man in my CD collection back home and the same man brought to life in Robert Mugge's stellar *Deep Blues* documentary a few years before.

Once my eyes adjusted to the relative dim, the room became very bright and almost animated. In what must have been a little country church back in the day, a local folk artist had really gone to town. Just about every square inch of wall and ceiling space had been covered with colorful paintings. Reproductions of *Ebony* magazine covers were painted on or near the ceiling—every bit as inspired as the Sistine Chapel. Nearly life-size scenes of clouds and sky, horses and beach covered most of the interior walls. The smaller spaces that lacked painted scenery were still thickly covered in bright glossy paint, generously sprinkled with metallic glitter.

I asked if there would be music tonight. "Not till dark," came the reply. It was only around 4:00 or 5:00 p.m. Conversation lagged. At one point, it was insisted that I shoot a game of pool. After a few shots, the handful of local observers rolled their eyes and went outside. As a pool player, I can really clear a room.

After what seemed like years, local customers and musicians started to roll in. Slow chaos ensued as different bands hooked up different equipment. Players came in and then left again to drive miles away in search of forgotten cords or amps. Junior Kimbrough was the bartender, selling ice-cold cans

James "T Model" Ford drinking at home (Greenville, Mississippi, 2009).

of Bud from a well-used plastic cooler. It was a dollar a can 'til the music started. Then, it went up to two.

For free, you could sample some white whiskey, aka white lightning or moonshine. It tasted vaguely of the corn that made it and the plastic milk jug that held it—powerful stuff.

Just before never, the music finally started. It rocked and rolled, it grooved and gelled late into the night. Another area recording artist, R.L. Burnside, and his extended family all played. A guy from Oklahoma City named Ray Drew performed. And of course, Junior Kimbrough and his clan took the stage more than once. His music, in particular, was mesmerizing, hypnotizing and many other "-izings," as it swept over and enveloped me. There were lessons to be learned that night. The main one I took home was that you can take the blues out of Mississippi, but you can't make it feel the same. No matter how good the record or how good the tour, this whiskey ain't the same when you pour it into a different bottle.

Basking in the moonshine of a muggy Mississippi night, my life was forever altered. I awoke the next morning in a dingy Holiday Inn a changed man.

About six years later, in spring 2002, I left the warm, comfortable arms of Corporate America and charted a course for a fabled land. Mississippi: my home of the blues.

"WHY'D YOU MOVE TO HELL?"

That was an actual question a middle-age white woman asked me upon my move to Clarksdale, Mississippi, in May 2002. She'd grown up there and apparently wasn't happy about it.

Clarksdale is a small dusty town of just under twenty thousand people. Most would agree that its glory days are now behind it, and until recently, more people were moving out than moving in.

So, why did I "move to hell"?

I moved to Clarksdale to circle the wagons, to mount a defense, to help the last generation of cotton-farming, mule-driving, juke-joint playing bluesmen deeply inhale the final breath of this amazing tradition we call Delta blues. My idea was to help other like-minded individuals and entities organize and promote this uniquely American art form from within and by all means necessary.

Blues as a genre isn't dying. It's the last of the true, honest-to-Muddy, Mississippi blues characters that I'm worried about.

To be able to sit with a bluesman in his seventies, eighties or nineties and hear firsthand about chopping cotton, serving on a chain gang, playing rural house parties, making white whiskey or even trying for that proverbial "deal at the crossroads" is just plain amazing. These are incredible stories, often thick with truth and understanding.

I watch younger Mississippi musicians "learn" the blues through classes, books and videos. I even see a few who sit at the feet of the masters. For years to come, they will keep the music going and even tell a few of the stories—the tales about their mentors and grandparents. Future generations will enjoy their songs but know that they, like their music, have moved another few steps away from the land and time where blues began.

Blues is a genre now. It used to be a music and a culture.

Hidden History of Mississippi Blues

There is a monument on an old cotton plantation near Clarksdale, Mississippi, where the blues legend himself once lived. It reads, "Muddy Waters' music changed my life, and whether you know it or not, and like

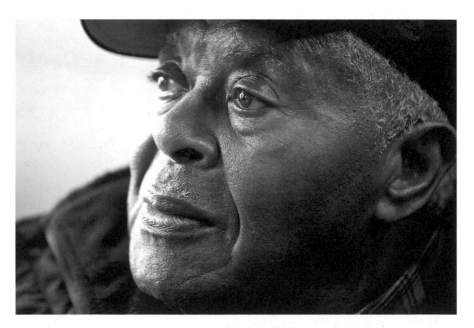

CeDell Davis relaxes after an interview at Sarah's Kitchen (Clarksdale, Mississippi, 2010).

it or not, it probably changed yours, too." It's a quote from rock god Eric Clapton. Replace "Waters' music" with "blues music," and you will better understand the reason for this book.

Rock, pop, soul, country, jazz, hip-hop, gospel and the next big thing all owe something to Mississippi blues. To paraphrase Mississippi-born blues great Willie Dixon, "Blues is the roots, the rest is the fruits."

At the beginning of the twentieth century, the field hollers and traditional spirituals of the post–Civil War, African American south morphed into something distinctly different: the blues. But unlike many other musical genres, this art form was (and still is) much more than just another type of entertainment. It is a culture full of hidden history. Life, death, love, war, truth, lies, rich, poor—it's all in there.

"I learned how to sing the blues out in the cotton field. Out in them lonesome cotton fields and stuff, I learned how to sing the blues": "Big" George Brock, seventy-eight.

"I told my girlfriend, 'Let's go.' She said, 'Uh, I'm going to stay. I want to hear *him* play some more.' He carried her home that night. That was a hurting thing. I went home and cried": Robert "Bilbo" Walker, seventy-two.

"I knowed the guy well that got shot, and I knowed the guy that shot him. The guy got stabbed on top of that. They thought he was dead. Next thing you know, the guy sat up": Cedell Davis, eighty-three.

"A guy came in behind me and stabbed me in my back. I whirled around and…cut his throat. He died. I wasn't mean, but I would fight. They sent me to the chain gang": James "T-Model" Ford, ninety.

"When I got to Parchman, I lost thirty-six pounds in probably ninety days. It was attempted murder…They were going to make an example of me": Mark "Mule Man" Massey, forty-one.

As these interview quotes suggest, part of the *Hidden History of Mississippi Blues* will bring the past to life through the reminiscences of the bigger-than-life characters who were there and lived to tell about it. These interviews are largely culled from my work with publications such as *Blues Revue, King Biscuit Time, Blues Festival Guide, Blues & Rhythm, ABS Magazine* and *Delta Magazine*. They illustrate part of the hidden personal histories so vital to the blues tradition itself.

Additionally, the volume you hold offers brand-new chapters designed to introduce blues history to new fans and reenergize existing ones. The blues, like any culture or art form, deserves to be studied and analyzed. But it is also fun. The music is infectious; the characters unforgettable. Hopefully, you will find this book to be an entertaining, thoughtful overview of the Magnolia State's rich blues heritage.

With the passing of each Mississippi blues veteran, decades of life experience and musical knowledge vanish into the Delta's rich alluvial soil. Stories go untold; songs go unsung.

An old African proverb, often quoted by blues scholar William Ferris, says, "When an old man dies, a library burns to the ground." Let us explore Mississippi's blues history while the library still stands, if for just a little longer.

Chapter 1

BLUES BEGINNINGS

The Archaeology of a Culture Barely Noted

"INDIANA JONES" OR "MISSISSIPPI PEABODY"?

Today, the Mississippi Delta is flat as a pancake and relatively treeless. It is mostly farmland, except for the occasional little town. Many of the old downtowns feature big brick buildings, sometimes worn and roofless, towering like Roman ruins from a boomtown past. These monuments now stand and remind us of the region's glory days done gone—the days when cotton was king.

Before this Delta landscape grew tired, before the days of King Cotton—before all of that—there were Native American tribes throughout the region. There were dense forests and swamps full of panthers and bears. There were tall Indian mounds and rich, long-standing cultures we can only glimpse from the twenty-first century.

In 1901–1902, the Indiana Jones of his day, Charles Peabody, came to Coahoma County in Mississippi in search of lost remnants from a past Native American civilization. What he found was more than just a pile of old bones or pottery shards. He found an altogether different culture as well, very much alive and (unbeknownst to him) in its formative days. It was an artistic foundation that was destined to change the future of popular music forever.

Fortunately for us, Peabody was from the north—from the Peabody Museum of Harvard University, to be exact—so this was all new and strange to him. Unlike many of his fellow white men who hailed from the highly segregated Mississippi Delta, Peabody didn't take what he observed

for granted or think it unimportant simply because it was a product of the local African American population. (Remember, slavery was still a warm memory in the south at that point, having ended less than forty years before.) As a scientist, Peabody's radar was always on, and what he observed felt compelling, maybe even important.

THE FIRST ARTICLE ON "BLUES" MUSIC?

A year after his return from the Delta, Peabody still could not forget his brush with black southern culture. In the summer of 1903, with the memories still fresh and vibrant, he published "Notes on Negro Music" in the *Journal of American Folk-Lore*. It is true that he never used the actual word "blues" to describe the music he heard (largely because no sheet music or record labels had yet coined the term "blues" to describe the genre). Still, through his vivid descriptions of the musicians and music, with consideration of the observer's time and place, it now seems clear that the work songs, hymns and "ragtime melodies" he witnessed were either the fringes of a blues art form already in place or the recipe for a blues feast soon to come.

Viewed over one hundred years since, Peabody's anecdotal writings are a treasure trove of musical folklore. For us, sitting here today, they are a bit like a blues excavation of an incredible archaeological find.

From "Notes on Negro Music":

> *I was engaged in excavating...* [an Indian] *mound in Coahoma County, northern Mississippi. At these times we had some opportunity of observing the Negroes and their ways at close range...Busy archaeologically, we had not very much time left for folk-lore, in itself of not easy excavation, but willy-nilly our ears were beset with an abundance of ethnological material in song—words and music...The music of the Negroes which we listened to may be put under three heads: the songs sung by our men when at work, unaccompanied; the songs of the same men at quarters or on the march, with guitar accompaniment; and the songs, unaccompanied, of the indigenous Negroes—indigenous as opposed to our men imported from Clarksdale, fifteen miles distant.*

Peabody also took the time to document some of the song lyrics he heard during his time in the Delta, and it is mind boggling how some of the lines still show up in present-day blues songs. For example, "Some folks

say preachers won't steal, but I found two in my cornfield," shows up more or less verbatim in a recorded song popularized by Muddy Waters ("Can't Get No Grindin,'" 1972) and is still sung today by Mississippi-born blues singers like Big George Brock and Jimmy "Duck" Holmes. "They arrested me for murder, and I never harmed a man" shows up in several later blues recordings, including Eddie Boyd's 1953 classic "Third Degree," also covered by rock-blues guitarist Eric Clapton in 1994.

One a final note, Peabody made this curious observation, regarding the plentitude of song within the black community and its deficit elsewhere: "They are in sharp contrast to the lack of music among the white dwellers of the district."

Even then, the musical foundation of the Delta's African American population, if primitive by modern standards, was culturally rich and rapidly developing.

THE FATHER OF THE BLUES

If you want a nickname or a description of yourself to stand the test of time, take a lesson from W.C. Handy. Put it in a book title.

Handy's 1941 autobiography, entitled *Father of the Blues*, forever married the author to his brilliant title, confusing decades of newbie blues fans in the process. (Handy did not invent or "father" the blues, though he did help popularize the art form, as we shall see.)

William Christopher Handy was a respected African American musician, author and bandleader in the early part of the twentieth century. Born in Alabama in 1873, he took an early interest in education and music as a way to escape his poor upbringing, later becoming both a teacher (albeit briefly) and a successful musical composer.

Besides gaining his "Father of the Blues" moniker via the title of his autobiography, Handy further secured the nickname through a tantalizing story of discovery recalled within the text. It is his first Delta blues memory, circa 1903 (the same year he moved to Clarksdale, Mississippi, and the same year Peabody published his observations above):

> *One night in Tutwiler* [, Mississippi, fifteen miles southeast of Clarksdale], *as I nodded in the railroad station while waiting for a train that had been delayed nine hours, life suddenly took me by the shoulder and wakened me with a start. A lean, loose-jointed Negro had commenced*

plunking a guitar beside me while I slept. His clothes were rags; his feet peeped out of his shoes. His face had on it some of the sadness of the ages. As he played, he pressed a knife on the strings of the guitar in a manner popularized by Hawaiian guitarists who used steel bars. The effect was unforgettable. His song too, struck me instantly. "Goin' where the Southern cross the Dog." The singer repeated the line three times, accompanying himself on the guitar with the weirdest music I had ever heard.

Handy went on to ask the musician about the song's meaning. From the man's reply, Handy came to understand that the singer was traveling to where the Yazoo Delta Railroad—nicknamed the "Yellow Dog"—crossed the Southern Railway in Moorhead, Mississippi, approximately fifty miles from Tutwiler.

From the musician's rough exterior and primitive slide guitar technique to the song's railroad subject matter and oft-repeated lines, it appears that Handy's firsthand observations provided the world's earliest written account of a solo, country bluesman at work.

Still, it wasn't this first blues encounter that led Handy to eventually name his autobiography (and himself) *Father of the Blues*. An epiphany still needed to occur—one that would turn the music he first judged "weird" into something that started to make sense: dollars and cents.

A BLUES COMPOSER IS BORN

While living in Clarksdale, Handy and the Knights of Pythias (his nine-piece African American orchestra specializing in the popular tunes of the day) took a gig in nearby Cleveland, some forty miles south. It was there that Handy experienced firsthand the profit potential of this newly crowned genre.

As he recalled in his autobiography:

I was leading the orchestra in a dance program when someone sent up an odd request. Would we play some of "our native music," the note asked. This baffled me. The men in this group could not "fake" and "sell it" like minstrel men. They were all musicians who bowed strictly to the authority of printed notes…A few moments later a second request came up. Would we object if a local colored band played a few dances?…That was funny. What hornblower would object to a time-out and a smoke—on pay? They

were led by a long-legged chocolate boy and their band consisted of just three pieces, a battered guitar, a mandolin and a worn-out bass. The music they made was pretty well in keeping with their looks...Their eyes rolled. Their shoulders swayed...I commenced to wonder if anybody besides small town rounders and their running mates would go for it. The answer was not long in coming. A rain of silver dollars began to fall around the outlandish, stomping feet...[Before long,] there before the boys lay more money than my nine musicians were being paid for the entire engagement. Then I saw the beauty of primitive music...That night a composer was born.

Born, indeed. According to Handy, that was 1905. Clearly, based on this and his earlier exposure to this "primitive music," blues had not only a foundation in the Delta by that point but also a following. If it could be popular there, then with a little smoothing and shaping, perhaps it could gain a following elsewhere.

The First "Blues Songs"

Nearly a decade after Handy's first Delta blues exposure, he published sheet music for a song entitled "Memphis Blues" (September 1912). While some have identified this as the first published blues composition, that first actually goes to Hart A. Wand and his song "Dallas Blues," published in March of the same year. Of course, neither composer would have called himself a "bluesman" at the time. Wand was actually a white man of German heritage who hailed from Topeka, Kansas, and grew up in Oklahoma City, Oklahoma. According to historian Samuel Charters, in his groundbreaking 1959 book *The Country Blues*, Wand probably first heard his tune (or at least its title and possibly its melody) from an African American porter from the south who worked for the young Wand's father.

While Handy's "Memphis Blues" was not, in fact, constructed as a typical blues song and included only a taste of typical blues lyricism, Wand's composition was presented as a twelve-bar blues and contained several bluesy lines.

Perhaps neither composition was truly a "blues song" in the cultural sense, but both helped to standardize a label for this burgeoning art form. Finally, this mysterious music of the American south had a name printed in indelible ink: the blues.

IS THIS THE HISTORY OF THE BLUES?

Why is it that we have to dig like Indiana Jones to find the beginnings of blues history? If what we call blues today began only a hundred-plus years ago, shouldn't there be more records (no pun intended) or eyewitness accounts in the literature? More documentation?

Again, note that Peabody (and, for that matter, Handy) was not from Mississippi or the Delta region where blues seems to have first appeared. This was a tough, fairly closed society at that time, and segregation was in full force. Frankly, it is very doubtful that most white people living in Mississippi during that era would have cared about the folk music of an illiterate black workforce. And let's face it: at that time, in this part of the country, it would have been whites who were writing down history. It took outsiders to note it, if almost incidentally, for posterity.

In the end, the furthest back we can take American blues history (without following its roots to Africa) seems to be around the turn of the twentieth century. It would take the coming of hit sheet music in the 1910s, popular records in the 1920s and AM radio in the 1930s and beyond to truly crystallize the blues as an important, recognized musical genre. And it would take the migration north of hundreds of thousands of African Americans, starting around 1915 (and reaching its apex in the 1950s), to spread the music—once and for all—from the cotton fields of Mississippi to the rest of the world.

Chapter 2

COTTON LIVES

Plantations, Floods and the Blues Migration

IS THE "MISSISSIPPI DELTA" EVEN A DELTA?

At my Cat Head Delta Blues & Folk Art store in Clarksdale, Mississippi, I often field questions like, "Why is the Delta called a delta?" Or, "What area does the Mississippi Delta cover?" The first question is appropriate because most reference books define a delta differently than the Delta we refer to in blues lore. The *Merriam-Webster English Dictionary*, for example, defines a delta as "something shaped like a capital Greek delta; especially, the alluvial deposit at the mouth of a river." Not very helpful in our case since our blues Delta isn't exactly triangular and ends some three hundred miles north of where the Mississippi River mouth empties into the Gulf of Mexico.

What the Mississippi Delta refers to, especially when discussed in a blues context, is northwest Mississippi's alluvial plain situated between the Mississippi and Yazoo Rivers. It appears quite pronounced on a topographical map of the region. Created by centuries of erosive river flooding and the receding waters of the Western Hemisphere's last great ice age, the Mississippi Delta is largely flat and richly deposited with topsoil sediments from all points north.

Historian James C. Cobb defined the Mississippi Delta as "actually more of a diamond or oval than deltoid in shape…approximately two hundred miles long and seventy miles across at its widest point." Author David L. Cohn probably provided the most-quoted definition of the area in 1935 when he wrote, "The Mississippi Delta begins in the lobby of The Peabody Hotel [in Memphis] and ends on Catfish Row in Vicksburg."

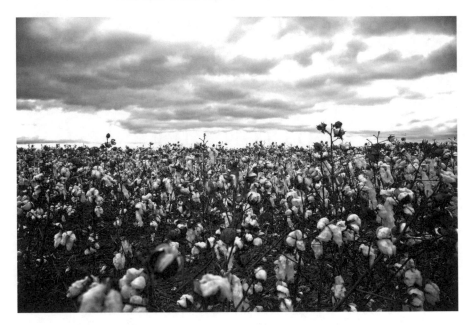

Delta cotton field at harvest time (near Clarksdale, Mississippi, 2009).

So why does any of this matter to music fans? It's simple. Without such a perfect agricultural setting of flat land, rich soil and hot climate, we might not have blues today.

GOLDEN BUCKLE ON THE COTTON BELT

Former Mississippi representative Malcolm Mabry once told me that folks called Clarksdale the "golden buckle on the Cotton Belt" back in the day, and it's no wonder. Even into the early 2000s, the miles upon miles of farmland surrounding Clarksdale were snow white with cotton every August through October. Today, ever-changing government subsidies and unpredictable economic trends have led to a growing mix of modern cash crops and less of an emphasis on cotton. Everything from catfish farms and rice paddies to soybeans and biofuel corn now takes up a notable percentage of the land's usable acreage. In fact, one recent U.S. Geological Survey report noted, "The Biofuels Initiative in the Mississippi Delta [has] resulted in a 47-percent decrease in cotton acreage with a concurrent 288-percent increase in corn acreage in 2007."

Of course, while that may be the case, late summer still brings plenty of bright white fields to much of the Delta. Enormous, diesel-powered, multirow cotton pickers drive through the cultivated lands day and night as huge rectangular bales of cotton line up next to the local cotton gins. Cotton may no longer be the almighty king that it once was during its heyday, but it is also far from a pauper.

A walk through Clarksdale's once booming, once cotton-fueled downtown still turns up reminders of the golden buckle's past economic glories. Even today, many of the buildings on Delta and Yazoo Avenues feature the remnants of skylights that once allowed cotton to be properly graded by natural light below. The bustling downtown was once home to cotton brokers, busily plying their trade. In the case of the current **WROX** Museum at 257 Delta Avenue, the words "Hopson 1920" are still set in stone high atop the building. "Hopson" refers to a nearby plantation that was once home to tractor-driving bluesman Pinetop Perkins as well as the world's first mechanically produced cotton crop.

For well over a century in the Delta, cotton has played an integral part in both white and black life, and even for those no longer directly tied to the agricultural industry, the effects still linger. From slavery times through sharecropping and into the new millennium, cotton's positives and negatives continue to affect the region's society, economy and music. And when it comes to music, simply put, cotton is the blues.

COTTON IS THE BLUES

Blues—the art form that led to rock 'n' roll and so many other modern genres—most likely came together in the steamy fields of Mississippi's cotton plantations at the end of the nineteenth century and beginning of the twentieth. Most of Mississippi's earliest blues performers spent much of their time living on the region's cotton plantations, either performing fieldwork or trying to avoid it by entertaining the other laborers. So it should come as no surprise that from almost the beginning of recorded blues, the music's practitioners have paid tribute to (or complained of) this infamous fiber. In 1929, two of the earliest Mississippi-born bluesmen to record sang of cotton: Garfield Aker's "Cottonfield Blues" (Parts 1 and 2) and Charley Patton's "Mississippi Boweavil Blues" (a song about the destructive beetle that plagued early cotton production). Even in modern times, Mississippi bluesmen have sung of cotton, from James Cotton's

"Cotton Crop Blues" in 1965 to Wesley "Junebug" Jefferson's "Meet Me in the Cotton Field" in 2007.

As Jefferson sang on his Broke & Hungry Records album of the same name:

> *My father was a sharecropper, farmed 10 acres of land*
> *All me and my brothers and sisters, we had to be there, too*
> *We had to chop the cotton, sometimes plant it*
> *But we was there, to help my father out*
> *When I was the age of four,*
> *I used to ride my mama's sack, down through the cotton field*
> *She picked the cotton, and I rode the sack*
> *I used to play with all them worms, crawling on the sack*
> *Mmmmm*
> *Well now, meet me in the cotton field, that's where you're gonna find me at*
> *You know, my father, he doing the best he can*
> *Now, you know we run around, without any shoes on*
> *If you looked at my back, I didn't have no clothes on*
> *I'm the son of a sharecropper*
> *I'm going to leave here one day, and I won't be back*
> *Meet me in the cotton field, that's where it all started*
> *I was at the age of four, I learned how to ride my mama's sack*
> *She said, "Hang on, 'cause I'm moving on"*
> *From sun up to sundown, from sun up to sundown.*

Jefferson confirms what many others of his generation have told me. As the son or daughter of a Delta sharecropper, your introduction to the cotton fields came early.

In the 2006 documentary film *Hard Times*, Mississippi-born bluesman Big George Brock recalled working the cotton fields as a young man and tied that experience to the blues:

> *The blues come from hard times. Blues came from a feeling that you got when you didn't have nowhere else to go, and the blues walked into your soul and into your mind, and it just accumulate like grass grow out of the ground. It just growed up in you. That's the way it growed up in me. I learned how to sing the blues out in the cotton field. Out in them lonesome cotton fields and stuff, I learned how to sing the blues.*

Out there, you just think about what you have, and you make your own self happy. I had a mule that if you didn't sing the blues, she didn't want to work right. And if you sing the blues, that mule, she'd work all day. You walking the cotton field, you walking the fields all day long. You just don't know how many miles you go in the run of a day. Them's a long mile.

They used to plant cotton with a mule. Now, they plant it with a tractor. Plant it, work it, grow it, pick it. They do everything now with tractors. But back in them days, they did it with these. You did it with your hands. We used to pick a bale of cotton a day, right here [on Flower's Plantation, just outside Clarksdale]. You had two rows, and this is the way you did this cotton. [Brock shows how to pick two rows, side to side, as he walks through the field.] *You grab this cotton like this, pick it, one row to the other, and put it in your sack. You go all the way up there, till you get all the way, and your sack get full. When your sack get full, then you have to go over there to the trailer and weigh that cotton,* [put it in the trailer] *and then come back and start right back where you left off at. Then, all day long, you pick cotton. And then when you get the amount of cotton that you want* [i.e., the trailer is full], *the amount of work you want, you took it to the gin—'cause the trailer would be sitting out there on the road.*

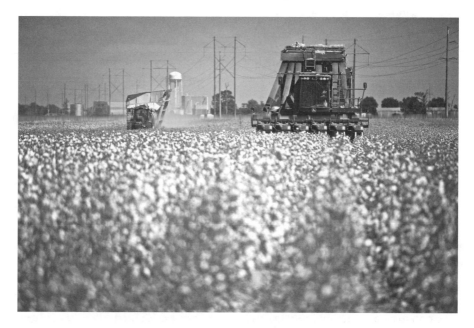

John Deere cotton pickers in cotton field (near Clarksdale, Mississippi, 2010).

Your nine-foot cotton sack is behind you. And you pull that nine-foot cotton sack. Well, if you weren't old enough, you had like a five-foot, or kids had like a four-foot cotton sack. But the grown folks, they had a nine-foot cotton sack, and they would be picking this cotton. See, these bolls on this here would eat my fingers up. These little sharp ends, there? [Brock holds up an open cotton boll to show the dry, pointy ends of the burr or husk that surrounds the cotton fiber.] *They would stick in my fingers. I always had big hands, you know, and it would just tear my fingers up. I never could pick much cotton on account of that. I couldn't take that. That's why* [you need to] *keep your mind occupied. You sing a song. Make yourself feel good. Your work go better. You forget about what you're doing, and it just come natural to you then.*

"Cotton Obsessed" in the Deep South

The late Delta folk artist Willie Kinard—perhaps best remembered for his wooden sculptures of the mythical blues "crossroads" at Highways 49 and 61 in Clarksdale—once told me a story about the mutual distrust between cotton farm workers and owners back when he worked at a particular white-owned plantation as a young man.

Kinard recalled that when the owner of this plantation passed away a few years back, he visited the farm in search of the owner's old cotton scale. The way that the old-style balance scale worked was simple. The filled cotton sack was hung on one end of the scale while weight was added to the other end until both ends balanced. This resulted in the official weight of the cotton pickings and, ultimately, the worker's per-pound pay.

After visiting with the widow for a few minutes, Kinard went out to the decrepit barn and located the now antique scale, which he took as a souvenir. Later, upon closer examination, Kinard found that the weight end of the scale—opposite the cotton sack end—had been modified. Its hidden hollow points had been secretly filled with lead. This discovery meant that the owner had been cheating his workers all along by underweighing the cotton and, therefore, underpaying them based on the "official weight."

Just as I began to react to the story with disgust, Kinard burst out laughing.

He went on to tell me that it was all OK because, in truth, he'd thought he was cheating the owner the whole time. Each time Kinard filled his cotton sack out in the field, he would sneak a heavy brick or two into the sack right

before weigh in. Then, after it was weighed, he would dump the sack into the trailer and toss the bricks to the side.

Still laughing, he explained that each of them thought he was getting the better of the transaction when, in fact, things probably just about evened out.

Unfortunately, most stories of sharecropping on cotton plantations are not so humorous.

Basically, the way sharecropping worked was like this: A cotton plantation owner (also called the "planter") would make a deal with a field worker and his family. They could live on the plantation in exchange for a percentage of the "profits" from a year's work in the cotton field. The owner would provide a house—often described as a shotgun shack (as in, you could fire a shotgun in the front door, and the blast would come out the back door)—and "furnish" the worker with basic food and clothing. This furnish was essentially an advance against future work and profits.

In a perfect world, if the planter had a profitable year, then the worker would share in the success. Unfortunately, that time and place was far from a perfect world. While some older, former sharecroppers will tell you of plantations that were "good" or "fair," many will tell you otherwise. Thousands of hardworking, uneducated African American sharecroppers felt they were exploited by the average plantation's long work hours, poor living conditions and low (or nonexistent) pay. Often these workers would be left owing the plantation owner money when a cotton crop didn't live up to expectations. Additionally, many plantations marked up the price or value of goods sold or loaned via onsite commissaries or company stores, making day-to-day survival all that much more challenging. Since the sharecropping system ultimately left most workers in debt, many felt that they were left with just two choices: continue to work in hopes of a better payday next year or leave in the dark of night in search of a better life somewhere else.

Sometimes, a worker's debt would also lead to conflict and racial tensions. Delta blues drummer Sam Carr once told me a story that left northward escape as his only option:

I started on my own [with my wife, Doris] *and tried sharecropping.* [They] *give me six or twelve acres of land to work. I go up there and get a pair of mules. Plow that land. I tried to make it with it best I could. Finally, I got into it with the boss. I wouldn't let nobody whoop me, but I would take a lot. Friday night, Doris cooked something. Saturday morning, we didn't have nothing to eat. So, I went up there and got with the boss. He said, "Lazy, son of a b——. When you leave that field, I want it to be plowed." I said,*

"Yes." My stomach's growling. So I tried to make it. But about 10:30 or 11 o'clock, we all left the field. One colored guy had an old A-Model truck. We come to Helena and get our furnish. So, we got our groceries and everything.

That Monday morning, the boss man come out there riding a horse. I said, "All right, I'm gonna try to reason with him." He come out there riding. "Lazy son of a b———. I told you to finish plowing this land." I said, "Mr. _____, I couldn't finish up. I got too hungry." "I don't give a damn how hungry you got. I'm gonna whoop your g——— ass." I had a crabapple switch. I said, "Mr. _____, you ain't gonna whoop me." "What you say n———?" "I said, you ain't gonna whoop me." Now, I'm mad and scared, too! He started off that horse. Man, I come up with that crabapple switch, and I hit them leggings and split them knickers. Them knickers flew off him like nothing. I don't know whether I cut him or not, but he went on. "We'll get you tonight!" He went to the shop. I went to the little ole one-room house me and my wife was staying in. I had an old single-blade axe. Well, when dark come, we run off. Police going around here looking at every black person you see. And we acted like we was lovers standing there waiting for the Eagle to run in Helena. That's what the train was named. I waited to be the last one to get on it. So I come on, bought me a ticket. I said, "St. Louis or Chicago."

In *Most Southern Place on Earth*, James C. Cobb writes:

In 1935…[sociologist] Rupert Vance identified the "cotton obsessed, Negro obsessed" Delta as "the deepest South," a region where one found "the highest economic range the south, with its peculiar social organization of black and white, may be expected to attain without industrialization." He was struck by both the "mansions" and the manners of the region's planter aristocracy—"affable and courteous with equals, commanding and forceful with inferiors"—but he noted as well that in the Delta the "Negro" was "to be found at his lowest level in America."

AFRICAN RHYTHMS AND SLAVERY DAYS

There is no way around it: 150 years ago, Mississippi was still a slave state. In the junglelike Delta region, slaves helped clear treacherous lands and then plant, harvest and maintain them, all at the behest of their white plantation owners. There was no pay. There were no rights.

Cotton Lives

It is true that the United States was not the first or only country with an active slave trade—far from it. And in some cases, blacks may have even sold other blacks into slavery in the cities and ports of West Africa. Still, at the end of the day, slavery in America, especially the American south, was an enormous institution that cannot be ignored in any serious study of musical history. In the Mississippi Delta, in particular, slavery loomed large in the growth of the region's settlement and economy. According to John Solomon Otto in his book, *The Final Frontiers: 1880–1930,* by the start of the Civil War, 84 percent of the residents in the Mississippi Delta were African American slaves. Slavery was big business, but in the Delta, it mainly meant that nearly impassable lands could actually be cleared and made ready for planting. Without African American slaves (and later, sharecroppers), it is unlikely that America could have had such a thriving cotton industry, let alone the music we now call blues.

It should also be noted that slavery and its main Mississippi export—cotton—made both southern planters and northern manufacturers quite wealthy. After all, just as the southern cotton plantations profited from slave labor, the northern textile mills and their associates made money from the harvest that slavery made possible.

From the periods of slavery and sharecropping, there came hard times and a greater need for renewed community, culture and entertainment among Mississippi's African American population. Slowly, imported African rhythms and tradition merged with the region's own plantation landscape and environment, ultimately evolving into something new and notably different. It was a music that had not existed before.

As a longtime blues fan, there is something distinctly uncomfortable about enjoying an art form born of such hard times. Perhaps, it helps to remember why this genre emerged as meaningful and necessary to the art form's originators and intended customers. As the traditional, oft-repeated lyrics sing, it is about "laughing to keep from crying." It is about picking one's self up and moving on. Whether one is singing about hard times in a cotton field or being dumped by a lover, the music is inherently about survival and making something good of bad. Of course, as the times have changed, so has the music; but at its core, it is and always will be an African American tradition from the deepest south, regardless of what other genres and subgenres it may spin off into.

WHAT IS "THE BLUES"?

Today, we live in a world of Facebook, MySpace, YouTube, Twitter and the next big social networking site. We live in a world of blues clubs that book rock music and blues festivals filled with white faces, both on and off the stage. Without the context of history, it is easy to skim the surface of any art form and merely see its modern-day representation. Therefore, it is worth pointing out that the musical term "blues" now has at least two broad definitions.

Blues, the popular art form, is a musical genre punctuated with blue notes and worrisome lyrics. It has a generally recognizable structure (often twelve bars) and is founded upon the iconic blues songs and musicians of history. Just as anyone from anywhere can legitimately sing a rock, rap or R&B song, anyone can sing a song and call it blues. In this case, blues is simply another style or genre of music.

Blues, the cultural art form, is the African American community's gift to the world. It is not just another catchy song or melody. It is the distinct result of the African's history in America—from slavery to sharecropping and beyond. Blues is the musical representation of a time and place that was thrust upon a common people of uncommon origins. The coming together of various African societies in the harsh pre–Civil War south meant that various African music and traditions were ultimately combined with Anglo American influences and instrumentations. After centuries of struggle and unconscious search for place, an evolution of art and music culminated into the tangible cultural art form we call blues.

Understanding this distinction, it's no wonder that *Living Blues*, a forty-year-old magazine published from Oxford, Mississippi, calls itself, the "Magazine of the African American Blues Tradition." That's what the blues is, after all: the tradition of a particular people and culture. It's a tradition built largely upon Mississippi cotton and, at times, the agricultural tragedies tied to it.

THE GREAT MISSISSIPPI FLOOD OF 1927

Today, when we hear about the Great Mississippi Flood of 1927, it is perhaps hard to imagine what an enormous social and economic disaster it really was. When considering its impact, think about Katrina. Think about recent tsunamis in far-off lands. Those are the kinds of natural disasters the event was akin to. The 1927 flood displaced families, killed people and

livestock, devastated farm lands and further ignited racial tensions already raw with history.

It's no wonder that whole books have been written on the subject. And it's no wonder that several of the blues singers of the day committed the disaster to song, including Bessie Smith, "Backwater Blues" (1927); Barbecue Bob, "Mississippi Heavy Water Blues" (1927); Memphis Minnie and Kansas Joe McCoy, "When the Levee Breaks" (1929); and Charley Patton, "High Water Everywhere" (1929).

In April 1927, after weeks of rain and a wildly rising Mississippi River, unprecedented tragedy hit. Some thirty miles south of Cairo, Illinois, a levee collapsed on April 16. Five days later, the levee was breached near Greenville, Mississippi, and soon covered much of the Delta town with some ten feet of water.

According to PBS's *American Experience* episode entitled "Fatal Flood," by April 25, "the situation in Greenville is dire": "Thirteen thousand African Americans are stranded on the levee with nothing but blankets and makeshift tents for shelter. There is no food for them. The city's water supply is contaminated...An outbreak of cholera or typhoid is imminent."

Plans were made to evacuate those who were stranded, but many African American sharecroppers were afraid to leave their town, and many of the white plantation owners were reluctant to let them go. The planters feared their black workers might leave the cotton plantations and not return, so instead of evacuating the workers, Red Cross supplies were called in.

After the floodwaters finally receded that summer, African Americans in the Delta again faced injustice and uncertainty, as Greenville's black workers were forced—in some cases at gunpoint—to dig the town out of the dirt and mud. In the end, perhaps 50 percent of the Delta's African American population left the region in the wake of the flood.

Called the most destructive river flood in American history, the disaster affected far more than just the Delta or even the State of Mississippi; its effects reached as far as Arkansas, Illinois, Kentucky, Louisiana, Missouri, Tennessee, Texas, Oklahoma and Kansas. Still, its negatives were probably felt most by the Mississippi Delta's African Americans, including the blues musicians and their fans.

THE BLUES IS ON THE MOVE

As a result of tough plantation life, challenging Delta economies, the 1927 flood and the eventual mechanization (and later chemicalization) of the cotton industry, a black migration from south to north began early in the twentieth century.

According to Mike Rowe's study of this great migration in *Chicago Blues: The City & the Music*, the first major northern migration by southern blacks began around 1915. During the decade of the 1920s, Rowe's census-backed figures put the "net loss [of African Americans] through migration from the South" at 773,400. This figure dropped by half in the decade of the 1930s, perhaps due to the Great Depression. But by the decade of the 1940s, the number skyrocketed to 1,597,000, resulting in a quarter of Mississippi's black population moving north. The effect on blues music was inevitable. As Rowe put it, "While segregation created the blues, migration spread the message."

The lure of more and better jobs in industrialized northern cities like St. Louis, Chicago and Detroit became the calling cards for tens of thousands of African Americans in search of a better life. These same job seekers were also the blues musicians' main, paying customers. As the fans moved north, so did they. Cities like Chicago, in particular, also offered a rapidly growing recording industry as well as dozens of live music venues and good "day jobs" for musicians.

And so Mississippi blues followed the trains, highways and Mississippi River north.

In fact, the biggest names of what became known as "Chicago blues"—from Muddy Waters and Howlin' Wolf to Sonny Boy Williamson II and Jimmy Reed—all came from the Magnolia State. They came in droves. Dozens of Mississippi blues performers headed north in search of fame and fortune. A few even found it.

These weren't the first Mississippi blues musicians to record, of course. There were earlier sessions that proved blues music was marketable during the era of so-called "Race Records."

Chapter 3

RACE RECORDS

Mississippi Blues Hits the Big Time

A HISTORY OF "RACE RECORDS"

It's difficult to confirm the first public use of the term "Race Records" or "Race Music," but it is now used to describe a recording period in the 1920s and '30s when both major and independent labels released music by and for the African American community. Some labels were owned or managed by blacks, though most were white-run. This was a time and place where "talkies" (movies with synchronized sound) were just coming into being, and television was in its early infancy. For news and information, people read regional newspapers. For entertainment, people saw shows, played piano by sheet music or, increasingly, bought records.

During the heyday of early blues, the average price for a new 78 rpm record was between thirty-five and seventy-five cents, depending on the label. The onset of the Great Depression caused some labels to lower their prices or start less expensive subbrands. As a point of comparison, U.S. first-class postage stamps cost between two and three cents each in the 1920s and '30s.

Furthermore, according to Livingfarmhistory.org:

> *Between 1929 and 1932, the average American's income drops 40 percent to about $1,500 per year. Milk costs 14 cents a quart, eggs are a nickel a dozen and bread costs 9 cents a loaf. During this decade, 86,000 businesses fail and 9,000 banks go out of business. In 1933 one-third of the U.S. working population is unemployed. By 1932, farm prices are about 65 percent of what they were about 20 years earlier.*

While most of the Race Records clientele wasn't making anything like the "average American's income" above, the plight of the overall Depression-era economy provides a useful backdrop for the rise and fall of a particularly important blues label, Paramount Records.

FROM CHAIR MAKER TO HIT MAKER

When you think of Delta blues, what state comes to mind first? Wisconsin or Mississippi? (I assume you are thinking the latter.) So, why then does Grafton, Wisconsin, figure so prominently into the early history of Delta blues? In a word, records.

Then, as now, a musician was typically judged successful if he or she had a widely distributed catalog of recorded work on which to base live performances, marketing, etc. Today, strong-selling CDs or mp3s signal success. In the 1920s and '30s, 78 rpm records were the ticket. And for the tired sharecropping bluesmen of the vast Mississippi Delta, the thought of a hit record was pretty inspiring. Sure, there was the lure of potential (though unlikely) big money but perhaps more than that, there was the opportunity to be recognized and respected for your craft and creativity. As blues icon

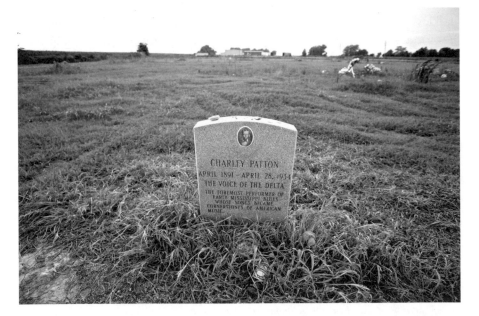

Charley Patton's grave marker (Holly Ridge, Mississippi, 2010).

Bukka White once said, he wished "to be a great man like Charley Patton," a famous recording star when White was coming up.

Paramount Records was founded in 1917 as a subsidiary company owned by the Wisconsin Chair Company. The relationship between the Wisconsin record label and its parent company had little to do with chairs but lots to do with another piece of "furniture" found increasingly in homes, stores, clubs and restaurants: the record player. Actually, what they started out manufacturing were wooden phonograph cabinets under contract for Edison Records. Eventually, the chair company began to press its own records, first under the Vista name (which failed) and ultimately under the Paramount label. Initially, Paramount recorded mainly pop music and no blues. That changed later after they contracted to press disks for Black Swan Records, an African American owned and operated label that targeted its own "Negro market" of the day. When Black Swan failed as a company, Paramount bought them out and, soon after, began heavily targeting this new, expanded African American customer base. It was a fresh market filled with untapped customers. The products would soon be referred to as Race Records, as they targeted the African American race, and blues history would soon be made.

RECORDING THE BLUES, 1930

During the height of the early Delta blues recording era, record companies were known to essentially conduct field-recording sessions, setting up makeshift studios in hotels and bringing in regional talent to record. In other cases, the talent had to travel. In one such case, a group of notable Delta blues performers traveled seven-hundred-some miles on the slow, sometimes suspect highways and byways of 1930s America for a recording opportunity.

The first significant Mississippi bluesman to record for Paramount Records was Charley Patton. In fact, songs based on his first Paramount hit, "Pony Blues," are still found in the repertoires of many Mississippi blues performers today.

Patton recorded twice for Paramount in 1929, and by 1930, he was arguably the label's biggest star. He was big enough, in fact, that Paramount entrusted Patton to find and bring along some new talent to his next recording session in the hopes of expanding the label's Delta blues success.

And so, on a warm spring day in 1930, Patton, along with bluesmen Son House and Willie Brown, loaded guitars and suitcases into the Buick of friend and gospel musician Wheeler Ford. They pulled out of Lula, Mississippi,

destined for Paramount's home base of Grafton, Wisconsin, but only made it twenty or thirty miles before the car pulled off the road at Kirby Plantation, just north of Robinsonville. (Robinsonville is what glossy, full-color brochures now call "Tunica," the gambling capital of the South). Patton had prearranged the stop, unbeknownst to his musical partners House and Brown.

As Stephen Calt and Gayle Wardlow described in their heavily researched, though currently out of print, *King of the Delta Blues: The Life and Music of Charlie Patton*: "The car's new passenger, House discovered, was Louise Johnson, Patton's 'side track' (secondary mistress)…Like her boyfriend…she 'didn't do nothin' but drink and play music."

As the story goes, the trip up to the Paramount session began with Patton and Johnson riding together in the front seat as lovers. After a stop for cheap whiskey and various arguments between the motley musical crew, the scene deteriorated to the point that Patton slapped Johnson. Louise Johnson, being tough like Patton, didn't just sit and take it. She climbed into the back with a surprised House. As the drinking continued, Louise Johnson and Son House found romance in the stuffy backseat.

Once in Grafton, the morning recording sessions at Paramount began. Over the course of less than a week, the four blues acts laid down around twenty titles. Not overly productive, the sessions did include the first recordings of Johnson, House and Brown. Sadly, the Willie Brown recordings were the only ones he ever made, and as it stands today, only two of the six songs are still in existence, or at least the other four documented sides have yet to be found. Somewhere, even today, they may sit silent and awaiting discovery.

According to *Paramount's Rise and Fall* by Alex van der Tuuk, the record label tried to stage further recording sessions with at least four of the Delta's earliest blues legends:

[Paramount] *tried to lure formerly successful artists back into the studio. Son House claimed that he, Charley Patton, and Willie Brown had been offered four-year contracts during their 1930 session. By the time House and Brown were asked to come back to Grafton to record, they already had started farming five miles north of Lake Cormorant.* [Paramount] *had written a letter saying, "I ain't got but a little of your stuff left on the shelves, we're running out, we want you to come back to make more." House did not respond, afraid of losing his job. Skip James* [was also approached] *several months after his session. James wanted to take his 16-year-old cousin with him, but canceled the session after the girl's mother refused to allow it.*

Sadly, by 1932, the writing was on the wall. The Great Depression was in full swing, and record sales were hitting rock bottom for the once-successful Paramount. Whereas the label had regularly pressed thousands of each new release in the past (only to repress more just a short time later), by the early 1930s, poor sales had led to a ghost of the label's former output. As Tuuk wrote, "Of the last few Paramount records pressed, hardly a dozen of each title were produced. These were 'first pressings,' which were sent to distributors as samples to generate orders. But the results must have been nugatory, as no followup [sic] pressings were done on these very last Paramounts."

OTHER BLUES LABELS OF THE ERA

Paramount was far from the only significant music label of the time to promote Mississippi blues. Okeh featured acts like Mississippi John Hurt and the Mississippi Sheiks. Victor released classics by Tommy Johnson, Gus Cannon and others. Vocalion issued recordings by the legendary Robert Johnson, among others. Other labels of the era to release so-called Race Records included Black Patti, Black Swan, Emerson, Gennett and Columbia. Still, Paramount looms large in the eyes of most blues collectors.

WHERE ARE THOSE WONDERFUL RECORDS?

Through the years, many have speculated as to what happened to the metal master recordings and remaining record stock after Paramount succumbed to the dead years of the Great Depression. Later interviews with managers and employees hinted at everything from metal masters used to patch holes in chicken coops to vintage 78s being dumped into the nearby Milwaukee River. The latter legend was even explored on national television in 2006 when PBS's *History Detectives* visited Grafton and dove in the river in search of long-lost, antique recordings. Unfortunately, nothing was found.

Occasionally, eighty-year-old Paramount recordings do pop up out of nowhere, though.

I was standing in my Cat Head store one afternoon when a young African American lady came through the door with what appeared to be some old records under one arm. She seemed in a hurry and a bit confused. She was looking for a gentleman who had recently arrived in town and was buying used records for resale. Since I knew where he was, I sent her on her way.

Twenty minutes later, the man himself came flying through the door. He was quite excited. With a smile on his face, he asked, "Guess what I just bought?" He was holding a well-worn 78 record of Charley Patton's "Pony Blues."

Crazy. Apparently, the lady who sold it had inherited it from a deceased family member. It had likely been sitting under a bed in someone's Clarksdale home for the better part of a century.

On another day, a noted record collector living in Greenwood, Mississippi, dropped by the store. After some small talk about recent blues happenings, he asked if I wanted to see his latest finds: a couple 78s he'd just picked up in Drew, maybe a half hour away. He proceeded to retrieve two lovely records by Charley Patton and Bukka White. Again, it is incredible that such ancient recordings somehow survived decade after decade of the Mississippi Delta's brutally hot and humid summers and generations of families coming and going.

Still, while splendid finds, these were songs that had already been found by past record collectors and transferred first to LP and later to CD for all of us to enjoy in the comfort of our living rooms. What about the records of legend that were allegedly recorded and maybe even released but never located?

More Than Just the Music Survived

In 2003, I called a man named John Tefteller in Grants Pass, Oregon. The self-proclaimed "World's Greatest Record Collector" had recently issued a 2004 wall calendar containing rare Paramount Records advertisements and a stunning long-lost, full-length photo of Charley Patton. I wanted to stock his new calendar at my blues store and was curious to learn the history of his wonderful finds.

As Tefteller told the story, the vintage ads and photos were found by happenstance nearly thirty years ago by some reporters in Grafton, Wisconsin. The newspaper there had recently changed hands, and decades of old advertising materials were being cleared out and thrown away. The reporters rescued the stacks of interesting-looking artwork from near the paper's dumpsters. They divided up their find and carried on with life, apparently unaware of its true significance.

In 2002, Tefteller heard about the collection and immediately purchased everything, thereby assuring the materials' preservation. The following year, he began the process of sharing this amazing find with the world.

His real passion, of course, was locating lost recordings.

In 2006, there came another seemingly impossible find. Tefteller tracked down a long-rumored Son House record, doing whatever it took to claim it. According to a 2009 *New York Times* article recounting it:

> *In 2006 Mr. Tefteller also purchased Son House's "Clarksdale Moan"/"Mississippi County Farm Blues," another long-missing Paramount release. "I know the name of the person I bought it from, but he's very paranoid and doesn't want anybody to talk to him," he said. "It was found somewhere in the South is all he would tell me, and I think he got it from the person who actually found it, but I don't know. The more I pressed him, the more it was clear if I didn't shut up, I wasn't getting the record. I shut up and paid him." Mr. Tefteller declined to specify the purchase price. "Let's just say tens of thousands," he said.*

You can see photos and hear samples of some of Tefteller's discoveries at http://www.bluesimages.com.

BLUES RECORDS TAKE TO THE AIRWAVES

As blues music began to spread beyond Mississippi's borders via Race Records, newspaper ads and a growing northern migration, another means of distribution was evolving. It was a new medium that would soon bring blues into Mississippi homes via the airwaves and carry the music's message far and wide.

Blues radio was coming, bringing with it brand-new stars and a fresh generation of fans.

Chapter 4

RADIO DAYS

The Golden Age of Radio—and Blues

RADIO DAYS: BLUES COMES HOME

Depending on your age and where you grew up, you may or may not understand the importance of radio in the early to mid twentieth century. I remember hearing my parents and grandparents talk about their favorite radio shows from youth, and I inherited my maternal grandmother's simple brown Bakelite radio set. Its open back was full of tubes, and it received only AM frequencies since there was no FM at the time of its manufacture. It is the radio that announced a "day of infamy," when the Japanese attacked Pearl Harbor and the radio that declared VE and VJ Days—when our boys were finally coming home.

Before families huddled around a box full of moving pictures to watch Elvis or the Beatles on Ed Sullivan's TV show, they huddled around the family radio to catch the latest news and entertainment. This was true in the industrial north as well as the agricultural south. In the days before TV or Internet, CDs or mp3s, this was how many first heard their favorite musical stars, including the legends of Mississippi blues.

A BRIEF HISTORY OF RADIO

As the 1800s crossed into the 1900s, a host of inventors, scientists and hobbyists worked individually or in unison to create what eventually became radio as we know it. Names like Edison, Tesla, Marconi and Hertz took part

in the quest, along with a lesser-known cast of dozens. By 1912, the United States was licensing radio stations.

Finally, in 1920, following intense governmental interest in radio technologies during World War I, the first regular licensed radio broadcast began emanating from KDKA in Pittsburgh, Pennsylvania. (The lead call letter "K" meant that the station was on the eastern side of the Mississippi River; stations with a "W" designation were on the western side.)

Like any new technology meant for the masses, it takes a while for the general public to catch on—or where potentially expensive hardware is concerned—to buy in. As more regular radio broadcasts came online and radio receivers (store-bought or home-built as "crystal sets," the very simple receivers popular in the early days of radio), the so-called golden age of radio began. The 1920s and '30s saw huge growth in the burgeoning industry, and the arrival of World War II in the early 1940s further fanned the flames.

RADIO WAVES REACH THE DELTA

Just weeks before the Japanese attack at Pearl Harbor, a small Delta radio station took to the airwaves in Helena, Arkansas, just across the river from Coahoma County, Mississippi.

It was a white-owned station, but many of its advertisers marketed their goods to black customers throughout the Arkansas and Mississippi Delta. Hence, the original King Biscuit Time blues radio show was born to sell flour to the region's biggest customers: African American workers and their families, most of whom were in Mississippi.

When I asked "Sunshine" Sonny Payne, the longtime host of King Biscuit Time, about the radio show in a 2007 interview for *Blues Revue* magazine, he told me how it all began:

> *In 1941, I heard they were going to open a radio station, and I went up and asked for a job. The station owners were Floyd, Franklin and Anderson. Win Floyd had a truck line business. John Franklin had a furniture store. Sam Anderson was John Franklin's brother-in-law who was principal of schools out of Barton[, AR]. He was smart as a whip, and he said you come by after you're out of school, and I'll get you a job. I told everybody I was going to be on the radio. Big time. So I said, "Well, I'm here. Which microphone do you want me to talk on?" He started laughing. He said, "After you run these errands, I want you to come back and sweep and mop*

floors." I said, "When do I get to talk?" He said, "When I tell you to. If you want to really be in radio, you're going to have to do it my way." So, we'd go down to the main studio across from Helena Wholesale Grocery on York Street. It was a big two-story truck line building, and we were on the top floor. And modern. Man, it was nice. You had to climb a bunch of steps, though. You had to go through three doors to get to the control room. One led to a little small studio. One led to a larger one. On Monday, Wednesday and Friday night, the engineer would spend an hour with us, teaching us how to operate the controls and also how to speak."

Of course, in 1941, two weeks after we opened, we had the blues. It was Robert Lockwood Junior's idea. He wanted to start something. He knew me since 1937. [He and Sonny Boy Williamson II] went up to the radio station, and I was sweeping the floors and getting ready to go out and pick up continuity [i.e., commercials]. They walked in. He said, "Uh, you think that Sam [Anderson] will talk to us?" I said, "I don't know. He's fixing to go to lunch." But I went and got Sam, and he said, "Well, what do they want?" I said, "Well, Robert plays guitar, and Sonny Boy, I think he plays harp. You know they play around here at one of the pool halls around the corner." So, Sam talked to them. They thought they could play music on the radio for nothing. There's so much controversy about how the sponsor entered into it. You know, someone will start a rumor about how they got started. The way the really and truly got started is this. Sam sent them over and said, "You'll have to have a sponsor." They went and saw Max Moore, the president of Interstate Grocery Company that distributed King Biscuit Flour, which had been on the market since 1930. So, as a consequence, [Moore] said, "I'll tell you what. I've got plenty of it in that box car out there that I can't get rid of. I can't give it away. I'll give you guys $12.50 a week [to play] 15 minutes a day, five days a week [on KFFA]. Then on Saturdays, I want you to play the Plaza Theater. We'll see if you can sell our flour. If you do, I'll keep sponsoring you." They got rid of that flour in a month. 30 days. Wham! Just like that. They did not say, "We'll play for nothing if you'll sponsor us." What they said was, "Mr. Moore, would it be all right if during our program that we could let people know where we're playing that night?" He said, "I don't care what you do as long as you sell that flour and get at least 3 songs in." So, that's how that program got started.

Ask just about any bluesman living in the Mississippi Delta in the 1940s and '50s, and he will tell you that he took a break from the fields, or wherever else he was working, around noon on weekdays and found himself a radio

tuned to 1360AM. Sonny Boy Williamson II became a blues legend largely because of these daily broadcasts, and other King Biscuit Time alumni such as Robert Lockwood Jr., along with Pinetop Perkins, Robert Nighthawk and Houston Stackhouse, benefited as well. Even today, blues performers from both the Delta and around the world drop in for a song or interview on Sonny Payne's now legendary radio broadcast. In 2006, the King Biscuit Time radio show celebrated its fifteen thousandth broadcast, and as of this writing, Payne continues the tradition most weekdays at 12:15 p.m. Archived broadcasts can be heard at http://www.kffa.com.

WROX BLUES RADIO CLARKSDALE

Across from my Cat Head Delta Blues & Folk Art store in Clarksdale sits a three-story red brick building. In front of it, there is a Mississippi Blues Trail marker identifying it as one of the important early locations of WROX 1450AM, the town's famous blues and gospel station.

Founded a block away in 1944, the radio station moved to 257 Delta Avenue in 1945; it remained there until 1955. The building is now the WROX Museum owned by Clarksdale businessman Bubba O'Keefe and operated largely by appointment. On its second floor, visitors walk on the same 1940s linoleum floors and between the same sound-tiled walls as did the day's important musical pioneers. Musicians such as Robert Nighthawk, Dr. Ross, Jackie Brenston, Sonny Boy Williamson II, Ike Turner and even Elvis Presley are said to have sung or talked into microphones there. (Sonny Payne also remembers broadcasting a few of his King Biscuit Time radio shows from Clarksdale's WROX studios, though that was at a later Alcazar Hotel location just around the corner.)

When you ask most native Clarksdalians about WROX, the first words they will typically utter (and always with a smile) are, "Early Wright." Wright was one of the South's first black deejays, and through his fifty years of hosting blues and gospel shows in Clarksdale, he became a household name. As locals tell it, he was apt to ask listeners to honk as they went by the station, and then he would acknowledge them on the air. Legend has it that he was also known to make up his sponsors' commercials on the spot, often adding promises like, "And if you come by the grocery right now, you'll receive a free loaf of bread." When listeners showed up asking for their free loaf, the confused store manager would hesitate until Early Wright's name was mentioned. He was nothing if not an effective salesman.

An acquaintance once played me a tattered cassette tape of Wright reading an advertisement for the Corner Grocery in downtown Clarksdale. After listing a sample of the store's selection that included beer, Wright spent the balance of the commercial explaining that while there was nothing wrong with beer, he didn't personally partake.

Through the years, WROX moved to multiple, mostly downtown, locations. When Wright passed away in 1999, even the *New York Times* paid tribute, calling him "a legend in the blues-drenched Mississippi Delta as one of the South's first black disc jockeys."

Shortly before Wright's death, WROX moved away from its blues and gospel roots, but in 2003, it hired West Coast deejay Steve Ladd to return the station to a blues, R&B and gospel format. I remember Ladd's first morning show at WROX. I caught the broadcast midstream, but as my clock radio clicked on, the sounds of an impassioned Elmore James and his electrified slide guitar woke me with a smile. Later that month, I began the *Cat Head Delta Blues Show*. Even after Ladd left the station and later passed away, I continued the radio show. Sadly, in 2010, WROX's blues programming finally succumbed to faulty equipment and a poor economy. Today, WROX is just another radio station playing "today's country hits." It is run by computer and features "deejays" recording their banter at some far-off studio. Still, back in the day, it and KFFA were *the* stations for promoting blues in the Mississippi Delta.

The Blues Moves to Memphis

In 1947, a radio station with the call letters WDIA began broadcasting from Union Avenue in Memphis. It began as more of a country and western–formatted station with lackluster results. Then, a year or so later, an African American columnist and teacher named Nat D. Williams started *Tan Town Jubilee*, the south's first black-targeted radio program. Soon after, WDIA ranked as Memphis's number-two radio station.

By the mid-1950s, future blues stars B.B. King and Rufus Thomas were hosting radio shows on WDIA, and a young rocker named Elvis Presley was making a name for himself with every spin of his latest hits. King, Thomas and Presley were all (not surprisingly) born in Mississippi, as were their biggest musical influences.

Blues radio was moving north and bringing its Mississippi musicians with it.

BLUES RADIO TODAY IN MISSISSIPPI

Today, the African American community still has stations and programming targeted toward it, though if it is not hip-hop oriented, then it is much more likely to be southern soul or R&B than traditional blues. Just as rock 'n' roll has evolved into something Elvis or Chuck Berry might not recognize today, so has blues. Radio stations that play blues in the black community are usually playing today's more contemporary edition of the genre: more beat, more synthesizer, more adult lyrics. For more traditional blues radio, modern listeners in the Magnolia State turn to the long-running *Highway 61 Radio Show*, emanating from studios in Oxford, Mississippi. Run on Mississippi Public Broadcasting stations throughout the state, *Highway 61 Radio Show* host Scott Barretta reaches thousands every weekend with a mix of blues that's often thick with Mississippi connections. Hear the show online at http://www.highway61radio.com.

BLUES RADIO TODAY—ELSEWHERE

Nowadays, you are more likely to hear Mississippi blues music toward the left end of the FM radio dial in a northern city than you are anywhere on the dial in Mississippi. Sure, it is likely late at night or on a Sunday afternoon, but community and public radio stations around the United States do help keep the sounds of Mississippi-born blues on the airwaves. There are also a handful of syndicated blues programs carried via some commercial radio stations. *House of Blues Radio Hour, Blueseum of Fine Art, Blues Deluxe*, etc. are but a few examples. Of course, many of them feature as much rock music as they do straight blues.

The biggest boost for blues radio in recent years has to be the advent and ensuing popularity of satellite radio: XM and Sirius. Bill Wax's blues programming on the *BB King Bluesville* channel, in particular, offers a nationwide outlet for today's blues acts as well as a window into the genre's history. Contemporary Mississippi bluesmen heard on the popular channel in the past include Big Jack Johnson, Super Chikan, T-Model Ford, Jimmy "Duck" Holmes, Pat Thomas, Terry "Harmonica" Bean, Bobby Rush, Terry "Big T" Williams and others. Additionally, Wax makes a weekly call most Thursday afternoons (5:00 p.m. EST) to my Cat Head store in Clarksdale to discuss upcoming blues happenings in the Delta. Such airplay and discussion promotes blues recordings, touring musicians and the State of Mississippi.

Radio Days

Blues radio may no longer rule in Mississippi the way it once did, but it does still spread the gospel of the blues far and wide. In doing so, it also drives blues fans and tourists to visit the fabled land where blues first developed—the land of the "crossroads."

Chapter 5

THE CROSSROADS

Robert Johnson's Deal with the Devil.

STANDING AT THE CROSSROADS

When you run a blues store in the Mississippi Delta, there are a couple of questions you're sure to hear each week. The first is: "Where can I hear some 'live' blues?" That's the easy one. The second one is a bit harder: "Where's the crossroads?"

Because the second question is so common and the very essence of Hollywood's rock 'n' roll version of the blues, *Blues Festival Guide* magazine (http://www.bluesfestivalguide.com) once asked me to tackle the subject. Much of this chapter comes from that article, originally titled *Standing at the Crossroads*. Thanks to all the interviewees who risked eternal damnation by speaking with me.

A DELTA LEGEND IS BORN

The blues story behind the so-called "crossroads" is simple, of course. A would-be musician named Robert Johnson wanted to learn to play guitar. After embarrassing himself in public a few times, legend has it that Johnson disappeared into the Mississippi Delta for a year or so. During this blues sabbatical, he took a late-night journey to a deserted place where two roads crossed and sold his soul to the devil in exchange for unprecedented guitar-playing abilities. When he returned, he could outplay anyone. He toured, recorded and found some amount of fame before the devil came to collect

on his part of the bargain. With that, Johnson surrendered his soul and died a slow painful death one steamy August night in 1938—or so they say.

Incidentally, it's interesting how things work. At my Cat Head blues store in Clarksdale, it's not so much the Robert Johnson music that sells; it's more the books and DVDs that explore the mystery behind the man, the mystery behind the crossroads.

Johnson first sang "Cross Road Blues" in 1936; Eric Clapton (in Cream at the time) covered the tune as "Crossroads" in 1968, and bands all around the world continue to pay homage to it today. In fact, a quick search through the database of one major CD distributor turns up over three hundred songs with crossroads in the title.

Asked about the origin of the Robert Johnson crossroads story, Bill McCulloch, coauthor of 2003's *Robert Johnson: Lost and Found*, said it goes back to the 1960s:

> *Our investigation showed that the first mention of Johnson selling his soul came in a Pete Welding essay (in* Down Beat*) in 1966 with the infamous quote attributed to Son House, "that Johnson sold his soul to the Devil in exchange for learning to play like that." In 1975 (in* Mystery Train*), Greil Marcus took the Welding quote, rephrased it to sound more like House, and used it to support a thesis that "selling his soul and trying to win it back, are what Johnson's bravest songs are all about." It was Marcus who really gave impetus to the soul-selling myth. Most of the pop-culture references to Johnson's devil deal came after 1975. The myth was also propped up by LeDell Johnson's colorful tale of how his brother, Tommy Johnson, sold his soul to the Devil at the crossroads. Somehow, the story got tangled up in the Robert Johnson legend. And of course, the Hollywood movie* Crossroads *went a long way toward cementing the soul-selling legend in popular culture.*

THE CROSSROADS ENTERS MAINSTREAM

Lost and Found coauthor Barry Lee Pearson agreed that it was probably the 1986 *Crossroads* movie that finally pushed the legend into the mainstream, as well as somewhat romanticized books like Robert Palmer's 1981 *Deep Blues*. But while attaching the crossroads tale to Robert Johnson may have stemmed from a quote in the 1960s and been sealed by popular cinema in the 1980s, the tale itself goes back much further.

The Crossroads

"I can't even remember when I first heard the crossroads story. Probably back in the '60s and '70s. Possibly when the record *King of the Delta Blues Singers* first came out," said Pearson. "It's a folk tradition that we find heavily in place in both Europe and Africa. It's the Faust story and could be thousands of years old. It's almost as popular as buried treasure stories."

Since first hearing the story, Pearson has interviewed numerous musicians who tell of hearing similar tales, usually involving a crossroads, a graveyard or even a certain tree. In most cases, however, the stories are not first-person accounts. According to Pearson, "More common are stories about people who did it." He went on to say that the most common element of these secondhand stories is that the participants "couldn't stand" the end result. "These are legends that are telling you 'Don't do that!' They're lessons." Of course, not all who heard these fables were turned off by them. Some relished such a devilish affiliation.

THE DEVIL'S SON-IN-LAW

In the 1930s, bluesman William Bunch, aka Peetie Wheatstraw, pulled from this folk tradition when he promoted two other more gutsy nicknames for himself: the High Sheriff of Hell and the Devil's Son-in-Law. "Peetie Wheatstraw is a guy who teased with that. It was pretty much fun and games," noted Pearson. Interestingly enough, more than fifty years after Wheatstraw's death, some elderly African Americans in his hometown of Cotton Plant, Arkansas, still remember Wheatstraw's tease. When a friend and I visited the town about ten years ago in search of Wheatstraw's unmarked grave, several locals quickly volunteered the musician's darker nicknames upon hearing his "Peetie" moniker. They laughed after speaking the nicknames aloud, indicating that this kinship with the devil may not have been taken too seriously. Still, like Robert Johnson, Wheatstraw did die relatively young at the height of his creative powers by less than natural causes. (In Wheatstraw's case, it was a one-car accident in East St. Louis. His father, a religious man, had the body brought back to Cotton Plant but would not allow the hard-living bluesman to be buried in the family's church plot.) Unfortunately for Wheatstraw, devilish nicknames and a violent death alone weren't quite enough to keep his name from the mere footnotes of blues history.

"In blues lore, Robert Johnson stands virtually alone as the only artist who is relentlessly portrayed as being in some kind of relationship with the devil," explained McCulloch.

HELLHOUNDS ON A TRAIL

According to Robert Mugge, director of 1999's *Hellhounds on My Trail: The Afterlife of Robert Johnson*, not everyone took Robert Johnson's crossroads legend so literally back in the day. While making the *Hellhounds* documentary, Mugge said, "My collaborators and I learned from Johnson's childhood friend Willie Coffee that no one took Robert seriously when he first said those things about selling his soul. They felt that he was just joking around."

So what about other musicians who knew Robert Johnson back in the 1930s? Did they believe he made the deal? "Everybody denies it except for Honeyboy. He says he doesn't believe it but that Robert Johnson said it," according to Pearson. Even as recently as five years ago, at nearly ninety years of age, Honeyboy Edwards still talked about it. "Robert had left. Before he left he couldn't play guitar. He was playing harp. When he come back, he was a bad man. Son House was standing on his head wondering how he like that," Edwards said. "I heard him say once that he went to the crossroads and sold himself to the devil like that. I wondered how could he do like that, but that's what he said he done."

Edwards searched for shortcuts to guitar-playing prowess, including trips to the crossroads.

> *When I was young, I lived in the country and went to the crossroads playing. In that time, people drank a lot of white whiskey. I used to get my guitar and I'd sit down right here at this crossroads, and I'd play the blues. Sit there and drink me some whiskey. Just sit down and play my guitar till I get tired and get up and walk on where I'm going.*

Asked if it improved his playing, Edwards quickly replied,

> *It looked like it helped me. And another thing that helped me, too. My daddy used to tell me to take my guitar when I went to bed at night and hang it up over my head. My daddy said, "Honey, you want to learn how to play guitar good? Hang your guitar up over your head there." Some of that stuff worked. 'Cause you go to sleep with it on your mind!*

The Crossroads

MAPQUESTING THE CROSSROADS

So what if Johnson really did sell his soul deep in the Mississippi night? Then, where is this elusive crossroads?

Through the years, Pearson has heard people tell of several possible locations in the Delta. "I've heard down on Leatherman Plantation," he said of one possible spot, adding, "I think that Highway 49 and 61 is highly unlikely." (The latter is the current location of Clarksdale's popular crossroads monument.)

Luther Brown, director of the Delta Center for Culture and Learning at Delta State University in Cleveland, Mississippi, agreed that 49 and 61 are unlikely but cited another possibility.

> *We regularly take visitors to the crossroads south of Dockery Farms* [the famous cotton plantation near Cleveland] *to talk about the story. Most people on a blues tour already know the basic story, and about a quarter have also seen* Oh Brother, Where Art Thou *which has the Tommy Johnson figure at the crossroads…If anyone "knows" where it is, they think it's in Clarksdale. I point out that the crossroads that's marked in Clarksdale didn't exist in that location during Robert Johnson's lifetime, but the one south of Dockery did, and he most likely did pass through it. I think it's fine for Clarksdale to commemorate their crossroads, although they should have chosen one that existed during Johnson's time, like the one at old Highway 49 and 61 nearer the historic New World District where Johnson would have hung out anyway.*

Does this mean that Brown believes in the crossroads?

> *I basically say that the crossroads is a metaphor for choice. We do talk about the sale of souls at crossroads though, which was actually a common belief in the '20s. I've spent some time in West Africa, and I know the mystery and apprehension that crossroads can have. Just last week, one of our tour group who was from Burkina Faso told me that in her country, it's not uncommon to find herbs or even a decapitated chicken at rural crossroads, left there by someone who performed a nocturnal ritual in private. This isn't selling one's soul, but it is propitiating a spirit, seeking advice or trying to affect one's fate.*

On the subject of possible locations, I asked Steve Cheseborough, author of the guidebook *Blues Traveling: The Holy Sites of Delta Blues*, to weigh in. Surely, if he wrote an essential blues guide to the Delta, then he must know where the real crossroads lies. In response, Cheseborough offered a story:

> *A few years ago, a guy working with some filmmakers asked me where they could find the "real" crossroads for their film. I told him about various spots. But he kept asking where the "real" one was. Finally, I explained that if they wanted to shoot pictures of Santa Claus, I could take them to the mall. But if they insisted on shooting the "real" Santa Claus, I'd have to tell them that Santa Claus is a mythical figure, not a real person. Well, that's how it is with the crossroads, too."*

Having said that, Cheseborough was also quick to add,

> *On the other hand, there is a sense in which the crossroads is real. I think Robert Johnson found himself at a crossroads after his young wife died trying to give birth to their child. He gave up his idea to settle down as a family man and farmer. He moved back to Hazelhurst and spent the next few years in intense musical study and practice before he began rambling and performing all over. He made himself into the artist we now know through his recordings. The real crossroads is inside you. If you want to go to a lonely country crossroads to perform a ceremony marking a transition in your life, sure, I can help you find one of those. Or you can do it at home, wherever you are—maybe by getting up, turning off the TV and picking up your guitar to practice instead.*

Whether the crossroads story is fact or fiction, it has clearly impacted the path of blues music in recent decades by introducing less than traditional blues fans to the music and building up the legend of a man who could have easily been lost to time. "I think people are naturally interested in anything that smacks of the supernatural," noted McCulloch. "The crossroads myth helped sell Robert Johnson's reissued recordings. And we can speculate that the myth might capture the imaginations of a few young people, who would then become more aware of the blues." Still, to some, that may not justify the myth's importance in discussions of blues history. "I would argue that the soul-selling myth does nothing to help us understand Robert Johnson. In fact, the myth serves to obscure the reality about Johnson and his culture," said McCulloch. Coauthor Pearson seems to agree and takes this argument

even a step further. "It diminishes Robert Johnson's contribution to African American culture. There are people who would find it slanderous," he said, adding that Johnson's family probably doesn't appreciate some of the soul-selling rhetoric. So what makes the crossroads story so appealing to new fans of the blues?

Mugge says:

> *Johnson was a brilliantly innovative singer, songwriter and guitarist, about whom little is known for sure beyond what can be gleaned from the handful of recordings he left behind...Many of his songs, coupled with stories told by those who purportedly knew him best, portray a darkly romantic landscape through which itinerant musicians traveled in search of adventure, profit and the perfecting of their musical craft. Add to that Johnson's image as a modern day Faust, and it probably was inevitable that, in death, both his music and his legend would prove far more influential than the man himself had ever been during his lifetime.*
>
> *[Bluesman] Robert Lockwood said he believed that a lot of people push these legends today primarily as a means of making money off of Johnson's life and work...I would have to add that, even taking the time*

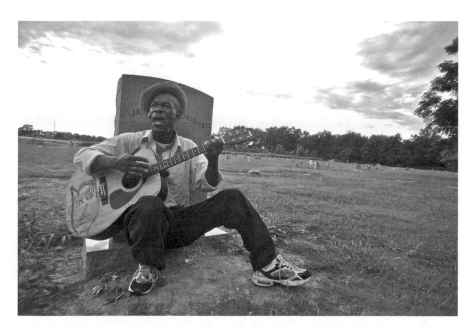

Pat Thomas playing guitar at his father's grave (Leland, Mississippi, 2009).

to debunk such legends involves playing the game along with everyone else. I truly believe everything that ever needed to be said about Robert Johnson was said a long time ago, and that from here on, we should just let the guy rest in peace. As I tried to suggest with my film on the subject, we and many others like us have now become the "hellhounds" on Robert Johnson's trail.

In the end, maybe the exact location and true nature of this Mississippi crossroads is less important than the land and legends that spawned the tale. Much has been sung, written and filmed about this tortured intersection. But maybe the only way to feel the power of this mystic past is to personally visit the land of the crossroads. Walk where the bluesmen walked and become a hellhound on the trail. Who knows? Maybe you'll find some answers or, at the very least, have a fascinating time trying. If nothing else, maybe you'll luck into some live blues at a local juke joint, just like back in Robert Johnson's day.

Chapter 6

JUKE JOINT

Just Another Name for Mississippi

SETTING THE STAGE FOR BLUES

Juke joint—two words often used, often abused. They contain an inherent promise of something real, something edgy, something from another time. Many music venues of suspect authenticity coin this phrase at one time or another, sometimes on a sign out front, other times in advertising.

Just as blues music is part and parcel of the culture that spawned it, the juke joint is as much a part of history's authentic blues landscape and people as is the State of Mississippi. I've explored the juke's past and present in articles for *King Biscuit Time* magazine (http://www.kingbiscuittime.com) and *ABS* magazine (http://www.absmag.fr). Here is a bit of what I found.

JUKES: A DELTA TRADITION

"Red's is a juke joint," its owner Big Red Paden, a self-proclaimed "old dinosaur," told me from behind his trademark sunglasses.

> *It's a place to let our hair down at, and talk with each other freely. It's a place to communicate at. That's the reason I have the building down there. The juke joint has been our [African American] play world. You know, you get out and blow off some steam. Then you go back to the house and get back in the real world again. It's just like a pressure valve. You have to release it. Then you go back home, and your mind is straight.*

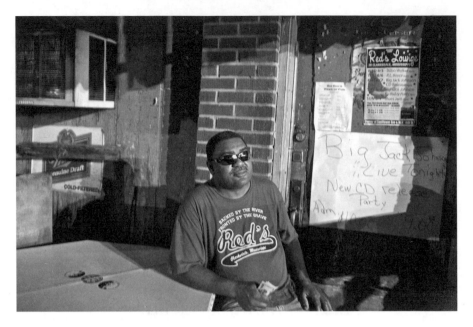

Red Paden collecting cover charges at Red's Lounge juke joint (Clarksdale, Mississippi, 2009).

For over a century now, there have been rough and tumble juke joints or something like them scattered throughout Mississippi, especially in the Delta. Much has been written about blues music in the past couple decades but not so much about the buildings where the music grew up and regular folks blew off steam after a long week on the job. "Some people think that because the building itself is old or raggedy and the blues being played is old or junk that it's a juke joint. But it's not really so. It's the people themselves that make the place a juke joint," according to Clarksdale blues guitarist Terry "Big T" Williams, now around fifty years old. "People back in my mother and father's day, or their mother and father's day, they were all party people. They would come out and try to forget about all the hard work they did throughout the week. It's called jukin,' and the place they did it in is a juke joint."

The late bluesman Wesley "Junebug" Jefferson played juke joints for decades and recognized early on why visitors and outsiders found them fascinating. "Some people want to hear something that's way back there," he said, "They are really interested in that. They know about the other stuff, but they want to pick up what they can get from way back there, you know. Something they didn't know about."

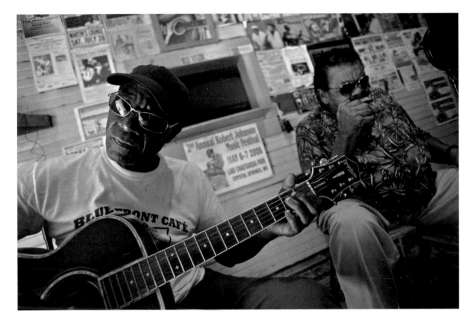

Jimmy "Duck" Holmes playing the guitar and Bud Spires playing the harmonica at Blue Front Cafe (Bentonia, Mississippi, 2010).

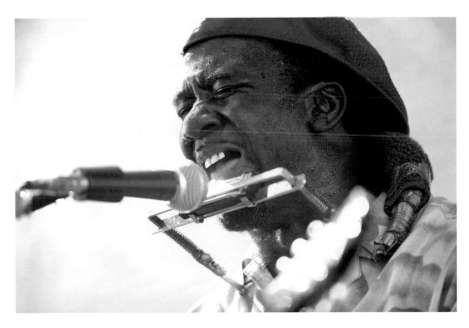

Terry "Harmonica" Bean playing at Cat Head Delta Blues & Folk Art (Clarksdale, Mississippi, 2009).

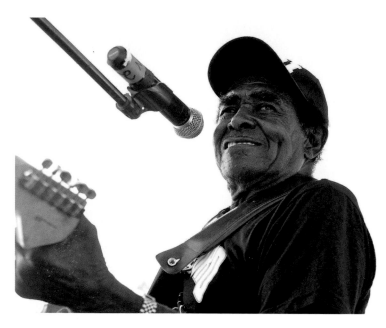

James "T Model" Ford playing at Highway 61 Blues Festival (Leland, Mississippi, 2010).

"T-Model" Ford's wife and grandson in their van after listening to music at Cat Head (Clarksdale, Mississippi, 2009).

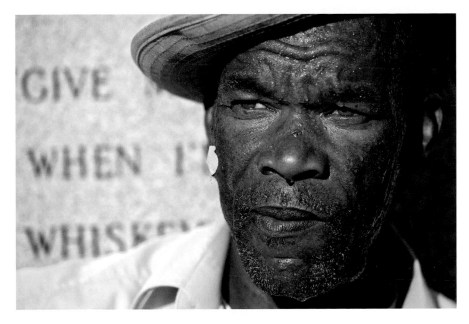

Pat Thomas, son of legendary bluesman James "Son" Thomas (Leland, Mississippi, 2009).

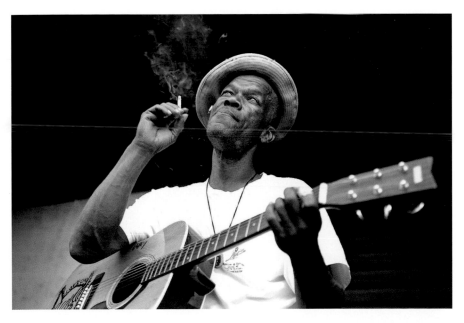

Pat Thomas, musician and son of legendary bluesman James "Son" Thomas, playing guitar in a box car in his hometown (Leland, Mississippi, 2009).

Robert "Wolfman" Belfour playing at Red's Lounge juke joint (Clarksdale, Mississippi, 2009).

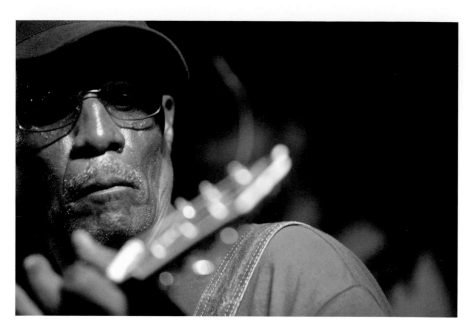

Jimmy "Duck" Holmes playing guitar at Bentonia Blues Festival (Bentonia, Mississippi, 2009).

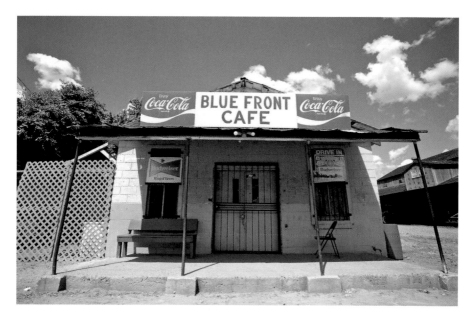

Jimmy "Duck" Holmes's Blue Front Cafe juke joint (Bentonia, Mississippi, 2010).

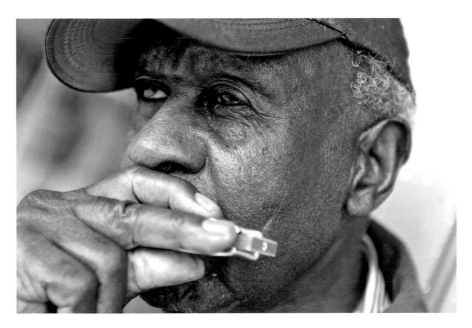

"Cadillac" John Nolden playing at the Bukka White Blues Festival (Aberdeen, Mississippi, 2009).

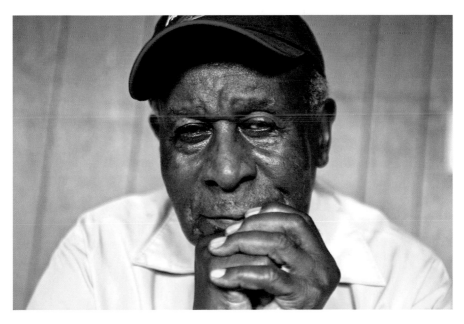

"Cadillac" John Nolden at fellow bluesman Monroe Jones's home (Cleveland, Mississippi, 2009).

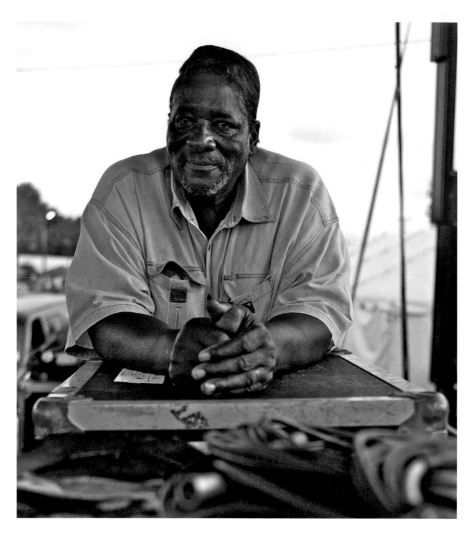

"Big" Jack Johnson preparing to go on stage at the Highway 61 Blues Festival (Leland, Mississippi, 2010).

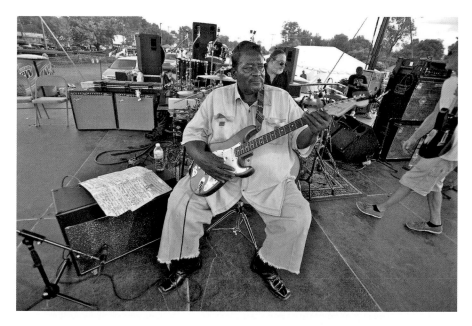

"Big" Jack Johnson tuning his guitar at the Highway 61 Blues Festival (Leland, Mississippi, 2010).

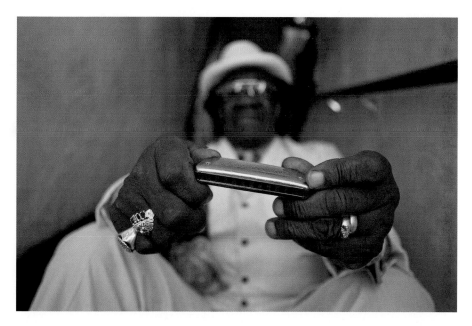

Mississippi's "Big" George Brock holding his harmonica at home (St. Louis, Missouri, 2009).

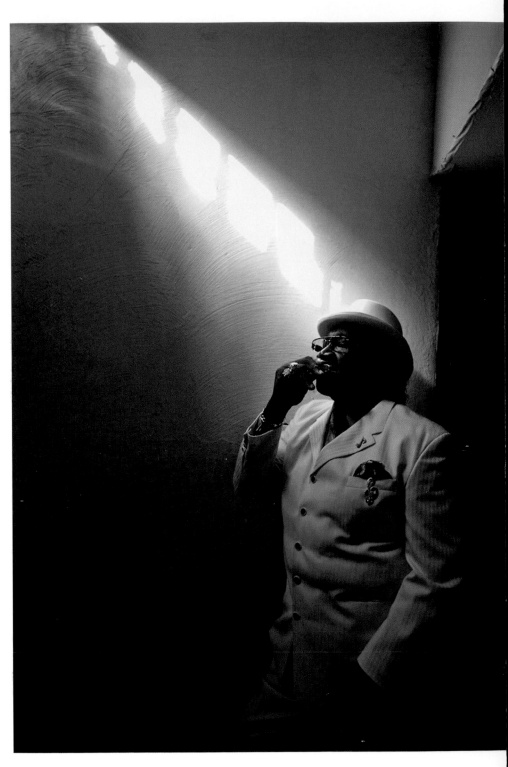

Mississippi's "Big" George Brock, in two different shots, at home (St. Louis, Missouri, 2009).

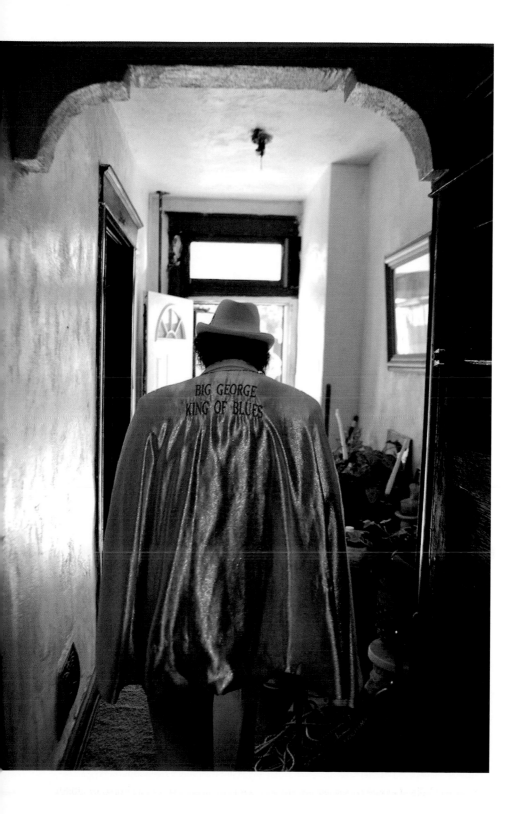

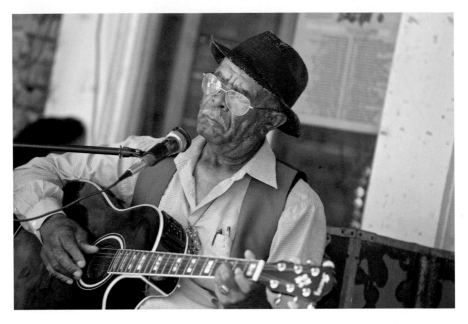

Robert "Wolfman" Belfour playing at Cat Head Delta Blues & Folk Art (Clarksdale, Mississippi, 2009).

Exterior of the world-famous Ground Zero Blues Club (Clarksdale, Mississippi, 2009).

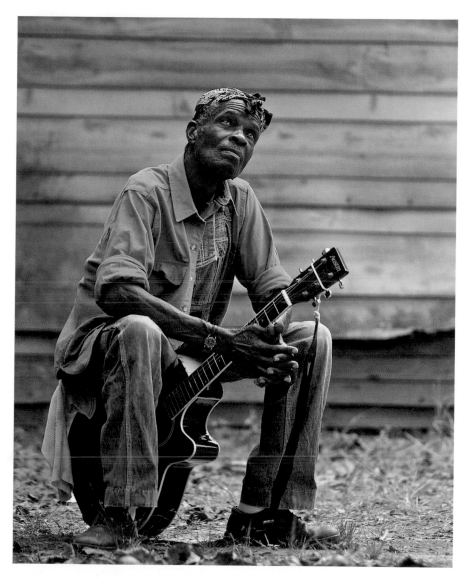

L.C. Ulmer rests on his guitar near his home (Ellisville, Mississippi, 2009).

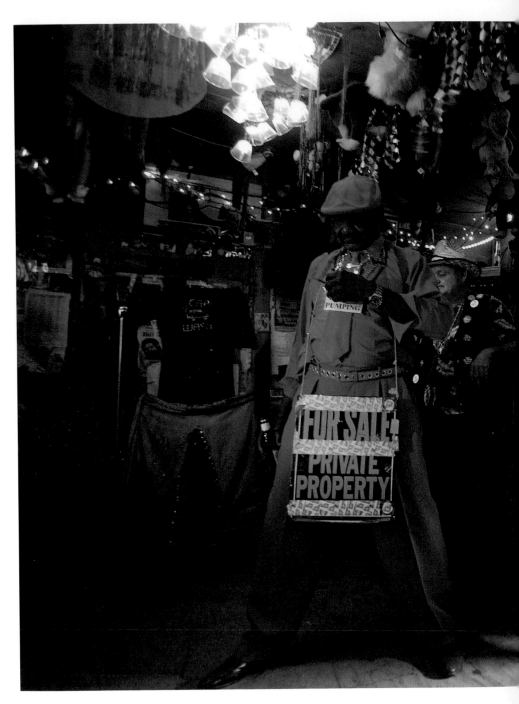

Willie "Po Monkey" Seaberry sells himself at Po Monkey's juke joint (Near Merigold, Mississippi, 2009).

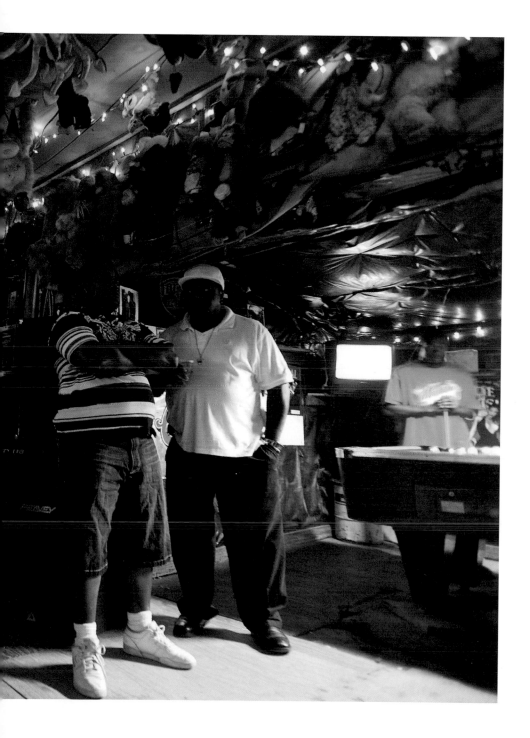

Willie "Po Monkey" Seaberry in front of his Po Monkey's juke joint. (Near Merigold, Mississippi, 2009).

R.L. Boyce jamming at one of his infamous Sunday gatherings (Como, Mississippi 2009).

As Williams put it, "People come here because they can't get real blues at home. You've got to go to where it's at. If they're serving real grits on this side, and they're serving powdered grits over there, then if you want real grits, you know where you've got to go."

Red agreed, adding, "Local musicians. That's basically what people from overseas want to see. When you go out and get big artists, it doesn't really tell the real story about what's going on in the area. We need to remember our roots."

Veteran blues characters like these grew up in the culture behind the music. As Jefferson told me,

> *I've been singing the blues since I was about eleven. Just singing and choppin' cotton, you know. Choppin' cotton and singing in one hundred degrees. Man, it was tough. I used to pray to move up somewhere and do something besides that. I left here in about 1956. I run off in the middle of the night. That's the way they done it then.*

After about thirteen years of working and playing the blues in Memphis, Jefferson returned to the Clarksdale juke joints. "When I started playing in

Anthony "Big A" Sherrod performing at Red's Lounge juke joint (Clarksdale, Mississippi, 2009).

Clarksdale, we had the Blue Diamond down by the railroad tracks and we had Red's place," he said. "I had a club at the corner of Yazoo and Martin Luther King. It was called the Chateau. It was my club. That was back in the '70s. And man, we had some great times there. They'd be waiting for me to open up because they'd knew we were going to play the blues." He referred to it as a "club," but by Jefferson's own definition, it was actually a juke joint. "A juke joint doesn't have any special rules much like a club would," explained Jefferson with a laugh.

> Sometimes you might hear some language you don't want to hear. And sometimes, every now and then, a little corn liquor might get passed around. You can go back to the cave days, and they had some little stomping ground, so it's a traditional thing. [A juke joint] gives me the feel of all the blues that's been there before. It gives me a feel for the blues more than a new place.

RED'S LOUNGE: THE JUKE ARCHETYPE

Red's Lounge is a juke joint, a Clarksdale institution that has helped keep the live blues alive in the Mississippi Delta despite trends in disco, rock and rap; despite downtrends in the economy; despite competition from corporate casinos; despite major building repairs; despite the passings of both musicians and customers.

Situated at the corner of Sunflower Avenue and Martin Luther King Drive, Red's has been around for about thirty years. Before Red Paden opened up his juke, the building was home to Lavene's Music Center where local musicians like Ike Turner bought some of their first instruments and blues fans bought the latest hits on 78 and 45 rpm records.

Red's Lounge is known for its well-worn exterior and dark interior. Every weekend, Paden books authentic Delta blues talent plus the occasional big name swinging through from out of town. Past performers include Big Jack Johnson, Frank Frost, Sam Carr, Watermelon Slim, Floyd Lee, Super Chikan, Big George Brock, James "T-Model" Ford, Robert "Wolfman" Belfour, Terry "Harmonica" Bean, RL Boyce, Odell Harris, Paul "Wine" Jones, Johnny Rawls, Jimbo Mathus, Terry "Big T" Williams, Wesley "Junebug" Jefferson, Robert "Bilbo" Walker, Mark "Mule Man" Massey, Anthony "Big A" Sherrod, "Mr. Johnnie" Billington, Jimmy "Duck" Holmes and many more.

Juke Joint

Before opening Red's Lounge, Paden ran the Tip Top Club just a block over on Martin Luther King Drive. He also ran a country juke off Highway 6 toward Marks, Mississippi, for a number of years.

To some, Paden is perhaps best known for his colorful sayings and they-broke-the-mold personality. Bart Cameron, a visiting correspondent from the Icelandic newspaper *Reykjavik Grapevine*, once wrote, "When we came in, Red shouted 'White People!' Then, when we aren't talking or drinking, he tells us that he's sure we work for George Bush." Favorite Red-isms include: "The game's for life," "I'm backed by the river and fronted by the grave" (his building sits, more or less, between a cemetery and a river), "There's gonna be some shootin' and cuttin' up in here tonight," "I kill for fun," "It's just proper procedure" and "It is what it is."

Red's has been featured in travel guides like *Blues Traveling* and coffee table books like *Mississippi: State of Blues*. It's appeared in publications as varied as the *Atlanta Journal-Constitution*, *Fortune Small Business*, *Garden & Gun* and *Life*. Blues tourists, reporters, rock stars and actors from around the world are not an uncommon sight at Red's Lounge. Big-name visitors include Samuel L. Jackson, Robert Plant, Morgan Freeman, Steven Seagal, Tom Waits and others. But Red treats them just like his other guests. Everybody has fun, but nobody gets nothin' for free.

Perhaps, Red's tourist visitors describe his place best.

From tripadvisor.com: "We pulled up in front of a place that could only be described as 'Sanford and Sonesque' and went inside. Now, if you like nice, clean 'chain places' with tables and crazy crap on the walls, this ain't it. But if you wanna hear real blues…get down to Red's." "Authentic. Real blues artists playing in a hole in the wall joint. So glad we went…a real piece of history."

These quotes are worth expanding on.

Today, you can count the number of authentic Mississippi juke joints that book traditional blues on a regular basis on just two hands. Fifty years ago, I doubt you could even keep count. Fifteen years ago, there were easily double the number we find today.

Even among the clubs that call themselves "juke joints," many now book more rock, rap or R&B than straight-up blues. Some have even dropped live music altogether in favor of deejays or karaoke. After all, live bands cost more money, bring more personal issues and take up more space. Why deal with the hassle when the paying customer is just as happy with a plastic box and some speakers?

To truly understand what all of the books, magazines and movies mean when they refer to an old-style juke joint, you really have to experience one for yourself. An evening spent in a crowded, sweaty, Delta juke with live

music, dancers and drink is as close as you can get to time travel. It's living history with one foot in the grave.

(Note: A good start is a trip to Clarksdale's Juke Joint Festival each April, http://www.jukejointfestival.com.)

OTHER MISSISSIPPI BLUES VENUES

In addition to the small juke joints that can still be found sprinkled through Mississippi, there are a few other larger blues venues worth mentioning.

The 930 Blues Club in Jackson consistently books blues and soul from Thursday to Saturday each week. Rooster's Blues Club in Oxford and the 308 Blues Club in Indianola also book regular weekend music, usually blues. It is in Clarksdale, however, where perhaps the region's best-known, most reliable blues club resides.

Ground Zero Blues Club (http://www.groundzerobluesclub.com) is co-owned by actor Morgan Freeman, gubernatorial candidate Bill Luckett and music promoter Howard Stovall. Because of its location at "ground zero for the blues" (hence the name) and its Academy Award–winning co-owner, the club has received a lot of publicity over its decade of existence. More importantly, for most of that time, it has also booked live Mississippi blues bands on a weekly basis, Wednesday through Saturday night. Numerous albums and films have been recorded at the club, and the venue has become a centerpiece of Clarkdale's tourism-based revitalization.

While not a "juke joint" per se, Ground Zero Blues Club does emulate the look and feel of a traditional juke, from out-of-season Christmas lights to mismatched chairs. The venue's goal is to present the best aspects of a typical "juke joint experience," along with reliably scheduled performance times, professional sound/lighting, a full kitchen menu and a comfortable environment. Located just across the railroad track from Red's Lounge, many visiting tourists visit both places, helping to make downtown Clarksdale that much more of a blues destination.

IS THE BLUES DYING WHERE IT BEGAN?

To paraphrase Mark Twain, "The death of blues has been greatly exaggerated." Each time a juke joint closes or a living legend gets called home, the death bell tolls for the entire genre.

Juke Joint

Fortunately, cultural tourism is a growth industry in Mississippi. There are more blues festivals, museums and markers in the Magnolia State than ever before. That said, the music's originators, innovators and flag bearers—the Mississippi Delta's surviving veterans of the cotton plantation era—are quickly sliding into history. When they are gone, the music will be forever changed, and the culture from which it came will be that much more obscured.

With that in mind, perhaps it's time for a trip into Mississippi's rich blues past, through the words of the men who were there and lived to tell about it. Pull up a chair, and let's talk history with Mississippi's last great blues generation.

Chapter 7

THE INTERVIEWS

Blues Voices: History in Their Own Words

DOWN IN THE DELTA WITH *BLUES REVUE*

Shortly after I moved from St. Louis to Clarksdale, John "Riverman" Ruskey dropped by my Cat Head store. His personal life and unusual business (taking tourists on canoe excursions of the mighty Mississippi) was leaving him with little time to write his Down in the Delta column for *Blues Revue* magazine (http://www.bluesrevue.com). Ruskey asked if I would like to take over, and with editor Ken Bays' support, I said yes.

 Much of the following material comes from my *Blues Revue* columns—though most of the introductions are new, all of the interviews have been reedited, and a bit of new material has been added. Thanks to *Blues Revue* for allowing me to tell these stories. A special thank-you goes out to all of the musicians interviewed. You are my heroes and inspiration.

DAVID "HONEYBOY" EDWARDS

Through Clarksdale's Juke Joint Festival, Sunflower River Blues Festival, Ground Zero Blues Club and my own Cat Head store, I have had the pleasure of booking Honeyboy Edwards for several live shows and public storytelling events. As a fan, I own pretty much everything he ever released, including CDs, LPs and mp3s. His autobiography, *The World Don't Owe Me Nothing*, is a personal favorite and should be a required read for anyone interested in blues or Mississippi history. Currently, even at the age of ninety-

five, Edwards continues to tour the world with his faithful manager and sidekick, Earwig Records (http://www.earwigmusic.com) founder Michael Frank. Thanks to Frank for arranging this interview.

Clarksdale, Mississippi—Then

"Clarksdale was a pretty town back in the '30s and '40s. On a Saturday, you couldn't get in. People come from Tutwiler and Rome. That was the town. Coahoma was a nice little town, too, but some of them would leave Coahoma to come to Clarksdale. Some of them would leave Friars Point.

"A lot of musicians lived around there—Raymond Hill and his daddy, and this other piano player, Ernest Lane. You take John Lee Hooker, he's from Clarksdale. I knowed all of 'em. Me and Ike Turner played together once or twice. I met Tony Hollins. He was a barber used to cut hair in Clarksdale. He made one little record, 'Crawling Kingsnake.' The one on the other side was about, 'I'm the only one in this town.' Tony Hollins, he didn't live too long.

"Pinetop Perkins drove a tractor out there at Hopson [Plantation]. He was staying out there back in '37, '38. We had a little juke on Hopson, but mostly Pinetop drove a tractor and played out at house parties around Lambert and Tutwiler. We played all around there, out to Jonestown and Lula up there at Jones Plantation.

"Muddy Waters used to stay in a little old house and drive a tractor there at Stovall [Plantation], not too far from Clarksdale. Big Joe [Williams] carried me to Muddy's house. I didn't know Muddy then, but Joe, he knowed everybody. He couldn't read and write, but he went everywhere and couldn't get lost nowhere. And Joe said, 'Well, we'll go down by Muddy Waters.' Muddy just had married, and he stayed on the plantation. Still played good guitar. And he was trapping in the woods, putting down traps for possums, coons, minks and things, and he made pretty good money. Mink hides and coon hides sold pretty good, but possum and rabbit hide wasn't no good— they was too soft. But when [Muddy] caught coon and mink, he had money. I think he had house parties every once and a while and sold white whiskey like that. All them hustled a little bit out there and played on the streets."

On Making White Whiskey

"At that time, a lot of peoples in the country would have dances, and there was a lot of people in the country making white whiskey. That's how they made their living. Other bootleggers would come in and buy three or four

gallons. Just like if I was a distributor, I made whiskey at my house—twenty-five, thirty gallons a night. If you're a bootlegger, you'd come by and get two gallons from me for three dollars a gallon. I'm making money 'cause I'm making about fifteen, twenty gallon. I ain't selling by no drinks. I'm just selling by the gallon. And the bootlegger, he get it from me and distributes, selling by the drink, selling by the pint. He makes his money like that. But I ain't got time. I'm making too much money selling by the gallon. You know what I mean?"

Son House, Willie Brown, Robert Johnson

"A big plantation was just like a small town. So many people on there, you didn't have to get anything from nowhere else 'cause it was on that plantation. In '35, I left and went to Memphis and played the juke houses when I was twenty years old. And I came back from there one Saturday, and I stopped at that place where Son House lived at. Him and Willie Brown and Robert Johnson played out there in the country at a place called Flowers Plantation. All of the houses was white, and when you go into the plantation, there was a lot of houses, and the juke house was on the left side, the last house. I got out there about six or seven o'clock, and they was cooking barbecue and drinking whiskey. Son House and Willie Brown and Robert was there. Robert was trying to play harp then. He was a tall, skinny boy and had one bad eye. I sat in and played with them. Willie Brown played that night. I loved to hear him play.

"Willie used to play at Lake Cormorant with Son House. He was a better guitar player than Son House. He had steady chords when he played. All of them come right in together and sounded beautiful. He wasn't a rough guitar player. Miss a chord? No, he didn't do that. He just a smooth sailor all the way through. About five-foot-eight, something like that. He was kind of fat and chubby. He had kind of a round face. Wasn't dark. Kind of medium color. [Note: Also mentioned in Robert Johnson's *Cross Road Blues*, there are no known photos of Willie Brown.]

"Robert Johnson didn't talk too much. I never heard him cuss. Robert liked whiskey and women and was kind of easygoing and played blues hard. Robert wasn't a rough rider person. He'd play the blues and then take a solo. He start playing the natural chord, then stop and take a solo through there. Then he'd just do everything he want to do through his solo, and then straighten back out again. That'd make his music right. And he was the first guitar player came out playing the blues where you make a chord, you stop

and add a turnaround to it. Most all the guitar players had some kind of little turnaround, but it wasn't like Robert's turnaround. In '37, his numbers was all over every town you go to…You hear everywhere, 'Robert Johnson, Robert Johnson.' And the other guitar players who been playing for years didn't have a thing going no way. That's what they couldn't understand."

Library of Congress Recordings

"One Saturday about one o'clock, I was in Friars Point playing on the square. I was playing with my harp around my neck and people's all around me giving me nickels, dimes and quarters. Someone else would come up and give me a drink of whiskey. I'd stoop down like this to keep the police from seeing me, and I get up, playing harp and blowing whiskey all out the side.

"Alan Lomax came there. Walked up in the crowd, man, with a book under his arm. I didn't pay him much attention. When I quit, he said, 'My name is Alan Lomax. I'm from the Library of Congress out of Washington. I'd like to record you.' I said OK, and he said, 'Give me your address, and I'll pick you up Monday morning.' He was driving a 1942 Hudson, brand new. It was a beautiful car. He pulled up in my auntie's yard that Monday morning. She wasn't used to seeing no big car. He said to her, 'Does Honeyboy Edwards live here?' She was scared. She said, 'I don't know. He be here sometimes.' She thought he was a detective looking to arrest me in that big car. He said, 'I'm Alan Lomax from the Library of Congress, and I'm supposed to take him to Clarksdale and make records with him.' She says, 'I'll go and see if he's back here.'

"I got up. Put my clothes on. Got my guitar. Got my rack. Put it in my pocket and everything. And we went on out on King and Anderson Plantation, the next plantation from Stovall. They got big schools out there, and he went out there and talked to the trustees. Rosenwald Schools, they called them. Before then, they was going to school in church houses and things. The government put up them schools, painted them brown with the white windows. And that's what I recorded in. That's off of Number 1 [Highway], that's the road coming out of Clarksdale, coming into Friars Point. We started about eleven o'clock, and about eleven-thirty come up a tornado storm. I mean a bad twister. Stopped us in the middle of the session. It was about an hour and fifteen minutes before we got calm and clear back again. I did about fourteen numbers."

The Interviews

Electrifying the Juke Joint

"Back in '39, they had a job come through the country called the 'high line,' and they came all through the country cutting bushes and weeds down and putting those long poles up. Putting electricity with the high line. This guy out from Tunica, he was living about six or seven miles out, on the river out there. He got him a Seeburg [jukebox] out there, and climbed the pole and hooked it up. That guy got up there, got him some snips, got some rubber gloves, put the rubber gloves on, got this rubber tape and stuff, and put them wires in there. He had a Seeburg going out there two or three years before they caught him. Had lights in his house and everything. They wasn't looking for that. Before then, the people that had electricity in the country, they'd buy them generators from Sears and Roebuck. They'd build a little house in the back behind their house, put the generator in it, and have electricity come out of there."

Gambling: A "How to" Guide

"The only way I gamble now is if I see a drunk fool somewhere, so I can drop something on him right quick. Then I'll take that money. But I don't take chances like I used to. Most people gambling don't know how to gamble. He just know when he win or when he lose. That's what he know. But as for cheating, they don't know. If you know how to put in something on a person...like you got a straight set of dice down there. I got a set just like you got. I can't miss with them. I got to hit you in the door, and I got to know how to get up quick. All them little-bitty bets, he win. But you get the big bets piled up on the bar. And you say, let me see your dice, man. Come underhanded like this. You shoot a couple times. 'Uh oh.' You say, 'You lucky, but you lose that time.' One thing about a guy, if he got $200, and he lose $125, he going to lose that $75 trying to get that $200 back. He ain't going to stop till it's gone. You got all the chance to make your money, and he ain't got no chance. 'Cause you know what's coming. See? He don't know. He's just gambling."

JAMES "T-MODEL" FORD

The (possibly) ninety-year-old bluesman lives in Greenville, Mississippi, and has recorded for Fat Possum Records, Mudpuppy Recordings and Alive Records. Some critics have alleged that Ford's rough and tumble image is

James "T-Model" Ford posing at home (Greenville, Mississippi, 2009).

the product of record-industry marketing, but I'm here to tell you that this man has lived the life. From surviving an abusive father to time served on a 1940s chain gang, from five failed marriages to his newfound fame as an international bluesman, Ford has ducked and dodged when he could—and fought when he couldn't.

(Note: The chain gang story included here comes from my piece in *Delta Magazine*, http://www.deltamagazine.com)

A Delta Bluesman Is Born

"James Lewis Carter Ford is my full name, but they call me 'T-Model.' That's because I was fast and my last name was Ford. Now, that's all anybody knows."

According to Ford, over half of his life had already passed before he became involved in the blues, and he didn't start playing music until he was fifty-eight.

"I done married my fifth wife, and I come in one evening. We had three little ones. She come out of the kitchen and said, 'Did you see your present? I bought you a guitar and an amplifier.' I said, 'Dammit, baby, what you spending my money on something like that? I can't play no damn guitar and

don't know nothing about no damn guitar.' She said, 'You can learn.' I said, 'You going to stay on with me?' She said, 'Yeah.'

"But next Friday night, I come in from work, and they'd done packed their clothes and left. That's when I picked the guitar up. I didn't know about that mother. I didn't know amps from bullfrogs. I could see two holes right at the side on [the amp], and three knobs on it. I got the cord out and stuck it in the wall. Turned one of them buttons. No damn light. Turned another button. No damn light. I thought, 'This ain't no good.' The next one, I turned it on down there and the light jumped on. I said, 'Uh huh.' Then I went back there and got the guitar. A pretty little Gibson electric. I looked at it. I plugged the cord in the guitar. I seen the two holes. When I stuck it in there, nothing happened. I said, 'This ain't no good.' I turned one button on the guitar. I turned another button on the guitar. And there was a switch down there. I hit that switch and 'boom, boom.' I said, 'Yeah, dammit!' I started a Muddy Waters song: 'I wished I had my baby on my right arm.' Sounded good to me. I started Howlin' Wolf. It was sounding sort of good. I didn't even know how to tune that thing. I fooled around there about three nights. I kept on. Damn! A week, and I'm the best. I been playing ever since."

Where did T-Model first take his music public?

"That was right over there [at home] at Hay Street in Greenville. All them people be in the cafe there. I got to playing that mother, singing them blues. Them people there was begging to come to my house. Next thing I know, someone is knocking. Two women. They come in. 'T-Model, your wife gone?' I said, 'Yes, she done left me. You married?' 'No.' I said, 'I know you got an ol' bad boyfriend around here somewhere.' 'Yeah, we on bad terms.' I said, 'Well, that's the same way I am. Me and mine on bad terms.' I said, 'But I need you tonight.'" [Laughs.]

The Boss of Nelson Street

"The first time I went on to Nelson Street [in Greenville] I was sitting on my porch. All them women was around me. They was dancing and drinking that damn corn whiskey. Here come an old man in a pickup. He pulled up in there and got out. He said, 'Why don't you quit wasting your time and go on and make you some money?' I said, 'Well, I don't know if I'm that good enough to make any money.' He said, 'You play as good as anyone play a guitar. [Local bluesman] Booba Barnes and them can't handle you.' He said, 'If I can get you to play tonight, will you play?' I said, 'Yeah.' He went on

down to this man's cafe that was just opening and asked him, 'Do you need a guitar player?' He said, 'Go get him and bring him down here. Tell him to play me three songs.'

"I got my amp, my mics. He helped me carry my stuff in there, and we sit down. So then I plugged up and started kicking that mother. He stood there and listen at me. Some of them guys was easing in there. Sitting down and listening. Drinking. I started playing another one by Howlin' Wolf: 'How many more years you going to dog me around?' He said, 'That's enough.' He said, 'What will you play for tonight?' I said, 'I don't know, sir. I ain't never played for no money.' He named me a price. He said, 'Will you play for thirty dollars?' I said, 'Yeah, man.' Booba and them wasn't making that kind of money! By eight o'clock, all the people done left Booba and them down the street and come in and lined the tables up. You couldn't get in that place. I was the boss of Nelson, and I'm still the boss of Nelson. I been the bad man ever since then."

Taking the Show on the Road

"Everywhere I played, I had a [full] house. The first man I played with was John Price. He was a drummer; he dead now. I was ashamed to go out of town back then. [One night], a horn blowed, and I went to the front door, and there was John Price. He said, 'Come on and go to Benard. We playing there tonight.' I hadn't been nowhere, so I was ashamed. 'I'll give you fifteen dollars to go play tonight. Booba and them is already up there playing.'

"We got in the station wagon and lit out. We got up there and found a parking place and went on to the door. Booba and them was up on the stage, blowing and playing. I just acted like I didn't know who the hell they was. Walked on and got a table. I was tasting that damn corn whiskey at that time. I had half a pint in my pocket. There was about ten people in there. Nobody was dancing. Booba and them was blowing and getting down. 'T-Model Ford? Get your guitar ready and come to the bandstand.' I got on that stage. [Harp player] Willie Foster stepped in there. That man could blow. Me and him and John Price started. I don't know where them people come from, but there were so many you couldn't get in there. They had to put two people at the door to take up the money.

"This guy, he come out and said, 'Price, where'd you get that man?' He said, 'I been hearing him but he was shamefaced.' 'That [expletive] ain't shamefaced. That [expletive] can play that guitar.' Booba come up, 'Look at that one-string [expletive], he done took the thing.' [Laughs.] He didn't like

me since. We played that Saturday night, and they hired us to come back for that Sunday, and somebody set that place on fire that Saturday night and burned it down."

Eventually, T-Model hooked up with Robert Nighthawk's son, drummer Sam Carr.

"It was me and Willie Foster and Sam Carr. One night, we played at Perry's [Flowing Fountain, on Nelson Street]. Booba and them had a band. David [Lee Durham] and them from Indianola had a band. Price had Frank Frost then. All them bands was there. They got on the microphone and announced that 'Willie Foster, T-Model Ford and Sam Carr is opening up for the night.' That was the most people I ever seen in that place. We was stomping ass, man. Boy, we had some fun."

Living Blues on a Chain Gang

"My Uncle Bill was messing with a girl that lived on the other side of [Humboldt, Tennessee]. They jumped him over there. I said, 'Do you know who it was?' He said, 'Yeah.' I said, 'You want me to go with you? Any fighting come up, I'm in the middle of it!' I could throw some fists then. So, we went on up there. Uncle was looking at the guy that had done the whooping of him. The guy's friend came by me, came out with his knife and grabbed on to me to cut. I throwed a bottle at him, and it killed him. Another guy came in behind me and stabbed me in my back, and I whirled around. I got my knife out and cut his throat. His knife was burning me like a piece of hot iron. Missed my spine by that much. He died, too. I wasn't mean, but I would fight.

"They sent me to Trenton, Tennessee, on the chain gang. They give me ten years, but I didn't stay but two. They put me in my stall at night. During the day, if you see a snake [when clearing land on the chain gang], you don't say nothing. If you say something, you going to catch it! Had one boy there. He had a whole lot of mouth. He seen one of them rattlesnakes laying around there. He said, 'Oh, look there's a snake!' Guard said, 'You found him. Now catch him!' [Ford motions like a guard with a shotgun.] So, it killed him. [Ford acts out being bitten by a snake.]

A Long Way from the Old Days

"I played in Australia with B.B. King. I like to have took his show. I got to whooping that guitar. B.B. King quit playing. He wanted to see what I was

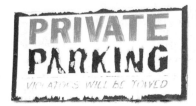

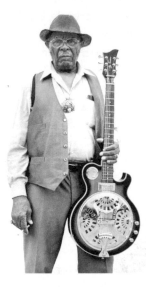

Robert "Wolfman" Belfour waiting to perform at Cat Head Delta Blues & Folk Art (Clarksdale, Mississippi, 2009).

doing. He didn't play no more. I ain't scared of none of them. Buddy Guy? I took him. [My drummer] Spam told him, 'Buddy Guy, you got a whole band. T-Model's just got the guitar and drums. He's shaking you!' He didn't like that too well. Everywhere I go, I'm the boss of Greenville."

ROBERT "WOLFMAN" BELFOUR

There may be bigger names and slicker packaging, but few blues players alive today sound as deep and original as Robert "Wolfman" Belfour. Like a visit to small-town Mississippi, listening to Belfour's music is like stepping back in time. His sound is old, pure and full, like two guitar players with one lonesome voice.

Born into the Blues

"I was born south of Holly Springs, Mississippi, and raised up in Red Banks. I was born September 11, 1940. I married in '59 and lived out there till '68. Then, I came to Memphis. I got tired of driving back and forth between Mississippi and Memphis every day to work.

"I don't have a lot of education. I finished fifth grade, and half the time, I didn't get to go then, 'cause my father died when I was twelve years old. It was in the wintertime, and he was out there riding his horse. Sometimes he'd get to drinking, and he'd drink so much he'd fall off the horse. He froze to death at the gate. He couldn't get through. The horse was still standing outside.

"I started playing when I was seven. I saw my father playing when I was just a little boy. I couldn't hold a guitar, but I used to watch him. And throughout the years, he started letting me mess around with it. I finally learned how to pick a tune on it when I got big enough to hold it up, and the first song I learned was "Baby, Please Don't Go." I used to sit and hear him play that. He played slide with the back of his pocketknife. I tried that, but I could never hold it right. I started out playing in natural tuning, and I learned how to change it from that to Spanish cross tune. I learned that from listening to John Lee Hooker. His records was popular then.

"I once did make a string upside the wall on the outside of the house. I put me a thing of baling wire upside the wall and put two snuff bottles under each end. I didn't know what note I was hittin' or nothin' like that. But I knowed by me running that little bitty bar up and down there it changed its tune. I got away from that after my mother whooped me. She didn't whoop me about playing that thing, she whooped me about driving those nails in the wall, 'cause water would get in the house through the wall.

"The first somebody I heard live was…I can't 'call his last name, but his first name was Cotton. I don't even know what part of Mississippi he was from. He had a cousin, somebody they called Puddin.' Those two are the first two guys I really heard playing other than Junior Kimbrough. I was about five or six the first time I heard him. He was a young man. He sounded about the same as he did before he passed. He'd learnt more songs, but he played in the same style. Later, I heard he had a club. He asked me down there quite a few times, but I never did have a chance to go down there before he died.

"When I was a teenager, I used to play at these open houses, you know. They give you a few dollars and all the white whiskey you wanna drink, all the fish you wanna eat. Places like that, anybody could play. Other than that, I think the first big thing I played at was Rust College in Holly Springs. I believe that was my first festival I played at. I believe that was in '82. From there I played the Southern Folklore festival in Memphis, the Chattanooga festival and the Knoxville Jubilee Arts Festival."

New Songs, Old School

"Hardly ever do I pick my guitar up when I'm around the house. I guess I should. Unless I'm working on new songs or something, then I do. You know, I sit around and try to learn the song good before I get ready to record them. I just write the words, and I space them like I want to. Then I sit down and put the music to 'em. I sketch it out on paper, then I take a typewriter and type 'em out.

"Some of the songs I learned by listening at the radio. If they come across my mind while I'm onstage I just play it. I mostly been sticking to my old stuff and some of the older guys' stuff. These younger guys that's playing now, I don't try to learn any of them. When I was really paying attention to the radio, I was more hung up on Muddy Waters and John Lee Hooker and Little Milton. But I mostly was more hung up on Howlin' Wolf. I guess that's why I do his songs sometimes, because that's really who I was influenced in when I was a young boy.

"I used to sit and play the music, but I was in my twenties before I would try to sing while I play. And when I did start trying to sing, I had a problem. That's when I was trying to play in chords. When I be trying to play and I sing the verse, I get screwed up with my playing. It throwed me off. So I started do everything by notes. I could sing better with that note than I could by going down here and finding the chord. I just left the chords alone, and I developed myself just to play by notes. It make the guitar say what I said, see? That's how I learned how to do it. I can hear the guys playing and where they're making the chords or whatever. When I hear them make the chords, I know exactly where that is on the neck of a guitar. I can't read notes or what key. But the sound I know, and I can find it on a guitar. After I quit hearing them, I can still find it."

The Future of the Blues

"There ain't nothing wrong with the old blues. Ever since I can remember it's been here, and I believe it still will be here when something else is gone. Somebody got to try to carry it on. I tried to, and I'm still trying to. And right about now, I'm around the oldest guy there in Memphis that's still doing it. I can be playing there on Beale Street, and I have people from all walks of life. They come there to hear me play because they can't find it nowhere else. All up and down Beale Street, you don't find people that play like I play. They got bands up and down Beale Street, but you know, they got the blues mixed in with the rock, and people don't like it. They want the real thing.

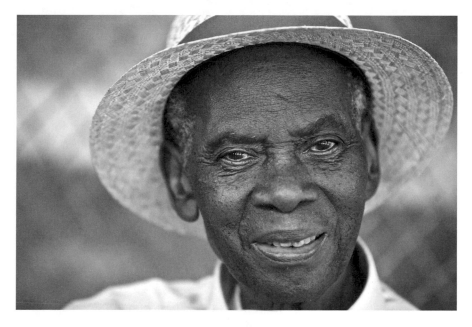

Legendary drummer Sam Carr photographed at Hopson Plantation (Clarksdale, Mississippi, 2009).

"There's just something about a guitar that just wouldn't let me let it alone. You know, I could put it down, and I could be in the field, whatever kind of work I was doing, I could put that guitar down for a week or two. But there was something that just bugged me to get a guitar and play. I don't know what it was, but something just bothered me to play. Long as I'm able to get around I'm planning to keep playing. But when I get to where I can't get around, I guess I'll have to hang it up. Every road has its end."

SAM CARR

The late, great Sam Carr may not be a household name, but he should be. He drummed with everyone from Robert Nighthawk (who was also his father), Sonny Boy Williamson II and Honeyboy Edwards to T-Model Ford, Floyd Lee and Buddy Guy. He's perhaps best known for his musical partnership with Clarksdale's Big Jack Johnson and Helena's Frank Frost in the Jelly Roll Kings band.

When I interviewed Carr, he was still living in a ramshackle house with his wife of many years in a cotton field near Lula, Mississippi. As we sat in his

living room talking, we were surrounded by dozens of photos and souvenirs from a blues life well lived.

Robert Nighthawk's Your Daddy

"The first time I seen my daddy was in 1933. He come by there, him and another old musician, in an old T-Model Ford. Mama Carr said, 'That's your daddy.' 'That's not my daddy!' The only daddy I knew about was them.

"I was about seven, eight or nine years old. I was running around there feeding the cows and mules, playing in the mud. He come by there. Robert looked like a boy. My mama called me. 'Here your real daddy.' 'Ain't none of my daddy,' and just kept right on playing. 'He ain't nothing but a boy, no how.'

"'No, sit down and listen. This is your real daddy,' she said. 'You have a real mama and real daddy. We're your stepparents.'"

Later, Robert was playing on Mother's Best Flour radio show, and I heard it. I had to be about nine, ten. He said, 'I come and get Sam and take him to Helena and buy him a gabardine suit.' So he took me there and bought me a gabardine suit, shirts and shoes. He said, 'Sam, I'm going to see if she'll let me keep you all night.' After I was asleep, I hear them playing music. That sound good to me. I'd never seen nothing like that.

"Took me back home. He said, 'I'll be back here sometime this year.' He did come back by during the wintertime, and he asked my mama, 'Let me keep him two or three days.' He was in Helena, and we was living right in this area [near Lula, Mississippi]. So, I went and stayed a night or two. He knew that was going to make me want to stay with him. The next year, I was growing up. He said, 'Well, you ever want to come stay with me, come on.' Well, that sound good to a boy, you know. So, sure enough, he come, and I stayed, I guess, a couple days, the way I can remember it. And come on back home. I was just about the age where I would leave home. I must have been about fifteen or sixteen."

Fooling Around with Music

"I was just now getting into fooling around with the music. So I stayed around here till I was about seventeen. And [Nighthawk] wouldn't let me play. He go out in the country and pick up boys and learn them how to play drums. But he told me that I couldn't cool soup! Said, 'You'll never learn to play drums.'

"[Carr's mother, Mary McCollum, would say,] 'Robert, you learned them other boys, sit down there and show them how to beat.' I'd slip around there when he be gone and play that little old piece he had. One day, he wanted me to work the door at a show, so he paid me for working the door. I was larger than I am now. Great big muscles.

"Playing out at this old man's place [in Helena], he was running colored and white, anybody who wants to come in, which that really wasn't happening, but he did it. I was bad back then. A big shot. So I come over here in Mississippi, and I stole my papa Garfield Carr's army .45. Everywhere I go, I have to show that gun. Some ol' bad boys might try to run me off the door. I kept that pistol right here. [Points to his waistband.] 'I take that,' they'd say. 'You might take what's in it!' 'Ain't nothing in it, no how.' Pow! Tin rattle on top the house. 'Put that away, boy, or you gonna kill somebody!' Said, 'That's what I intend to do if you try to take it.' Had no more trouble out of nobody, taking that fifty cents at the door."

Frost, Foster and Tree Top Slim

"I don't know how I came up with the first drums. I played somebody else's drums, I guess. Everybody I hired to play with me, they quit! Take their drums and guitars, amplifiers up. I told my wife, 'I tell you what. I'm going to buy me a set of drums.'

"I bought the drum one week. I bought the foot pedal the next. It took me a month to buy the drum set, and I went on. A little ol' boy named Tree Top Slim—he's a harp player, good harp. We went around there playing on corners. One day, some white man come down there, and he said, 'I'll give you two dollars apiece to play in front of my store from twelve to one.' Two dollars apiece? Man, we went down there. Then me and Tree Top Slim played, that's how I got started.

"Then there was this little boy there. He was playing with Willie Foster. Willie Foster would let Frank [Frost] blow the harp maybe one song or two songs. I was about eighteen. I said, 'You can blow the harp, man. How about joining up with me?' But he was so crazy about Willie Foster. I said, 'We could have our own band.' He said, 'All right.'

"I bought him a harp. So me and Frank got together. Frank couldn't play no guitar then. See, I learned how to play bass, sitting around listening to Robert. OK. Frank said, 'I got a guitar I give an old guy a dollar for, and I pawned it for a dollar and a half.' 'What kind of guitar?' 'I don't know, man. All I know is I couldn't play it.' It was a Hawaiian guitar.

"I said, 'Well, let's go to the pawn shop and see.' I think Frank bought it for three dollars. I went and got it, and said, 'Oh god. What is this?' So, we got it then, man. They didn't want it back. I went on home. I had an old Sears and Roebuck green guitar. Flat piece of wood. Ain't no telling what that guitar worth now. But I put that Hawaiian pickup in it. It sounded just like a Fender guitar. So, sit there and showed Frank what I knowed. Frank was easy to learn. And Frank went on from what I learned him there playing lead and bass. Wasn't but a little while, and he learned it the rest of the way. And Frank was good!

"Long, by and by, Frank could blow the harp with one hand and play the guitar. We sitting there at the house one night, I said, 'Frank, I seen a rack in the pawn shop. I'm gonna make you a rack so you won't have to use your hand up there.' I got me some pliers, a file. Got me some clothes racks. Bend it. Bend it some more. Curl it back around like I seen that rack. Frank bent it back a little more to his mouth and started blowing. 'We got it now, drummer! I ain't got to hold no harp.' And he did it."

At that point, Carr and Frost moved to St. Louis to live until family obligations forced Carr's return. "We played in St. Louis till my mama got sick. When I come back down here, Frank come with me. I said, 'I don't know when I'm gonna come back.' 'I'm going with you, drummer.' Frank had a woman he was staying with. I said, 'What about your wife? You gonna leave your wife?' 'Man, I ain't studdin' that woman, I told you. Let's go!'"

The Jelly Roll Kings Are Born

"Somebody told me about Big Jack in 1961 or '62. But if he can't play no better than Frank, I don't need him. If he can play half as good as me, I don't need him. I could play guitar then. So a guy brought Big Jack over there. Jack had a little ol' white guitar that was his brother's. Standing there holding it. 'Come on, man, play something.' 'I want to hear y'all first.' Frank could play the guitar then. Could play it good. When Jack come on, Frank was hot about that. He didn't want nobody in the band but me and him. 'I don't need him. I can sing. I'm the harp blower.' Frank could play piano. He play that piano and blow the harp and have the guitar laying down in his lap for whenever he wanted to play it. Frank was a good musician.

"So Jack steady standing there. I said, 'OK, man, you ready?' Jack says, 'I'm ready.' Said, 'I want you to play bass, and I don't want you to play no lead. Frank gonna play lead.' After that, Jack played. Jack fitted in pretty good. I asked him what songs could he play. Jimmy Reed, Muddy Waters,

The Interviews

Little Walter. We was just a perfect match. Frank felt pretty good about him. Took some of that weight off him. We played for years together. Jack had a little ol' job working at a baker's shop. He quit that quick."

"You a Little Ahead of Yourself"

At one point, the band took on a white manager in the pre–Civil Rights south.

"He took us and said, 'What if I was to take you all, have some suits made, and we travel all over the country? We could make something. I'm going to buy you a '56 Buick.' Man, it was right. Yeah, he dressed us up in white coat, black pants, shirt and shoes. I said, 'All right, we got our own clothes to wear, but we ain't got nothing like that.' I said, 'Don't you think you a little too early? Colored and white can't even ride together no kinda way.' He said, 'I done been from down here to Chicago, and I seen how everything works.'

"Well, where he made his mistake is he didn't tell the people he was booking the jobs with that he had a colored band. So when we went to play, the place was packed. People saw us coming in all dressed up with amplifiers and drums. We weren't no slouches. We were clean and sharp. Hair trimmed. When we get through unloading that stuff and setting it up, I'll bet you there weren't ten people left in there. Everybody getting their coats and leaving. 'What's the matter with these folks?' he asked. I said, 'You a little ahead of yourself.'

"A couple places we played, we had a problem with the police. Somebody told the police ahead of time that we were coming—that a white man had a black band. So the police stopped us before we got in there. One night, [our manager] was tired and sleepy. He was in the back of our car, asleep. Policeman said, 'What are you doing sitting back there, old man? Don't you know don't no n—— and white folks drive together? We ain't gonna have it.' And that was the end of that. I told him, 'It ain't gonna work. You just a little bit ahead of time.' We was glad to get back to playing by ourselves, because with them doctors and white ladies in the clubs we was playing, we couldn't drink whiskey and have a good time."

JIMMY "DUCK" HOLMES

Holmes lives in the tiny town of Bentonia, Mississippi. He is the last local musician to play the so-called "Bentonia School" style of blues, following in the footsteps of legends like Henry Stuckey, Skip James and Jack Owens.

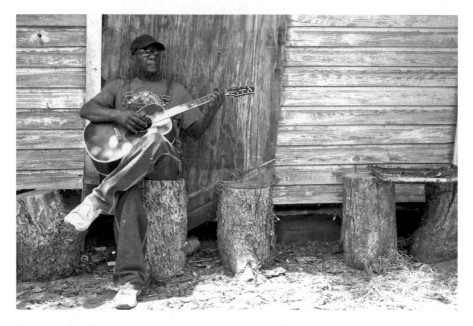

Jimmy "Duck" Holmes playing guitar next to his Blue Front Cafe juke joint (Bentonia, Mississippi, 2009).

Until recent years, Holmes was just a name in the margins: the owner of the Blue Front Café juke joint and a bluesman with a handful of unissued field recordings. Then, Broke & Hungry Records came calling in 2005. Today, Holmes is a mainstay of southern blues festivals and the occasional tour.

Born into Juke Joints

"I was born in 1947, and [the Blue Front Café] has been a part of my life since the early '50s. My dad done got it in 1948 when I was one year old. It's never been closed for nothing. My mama said musicians used to come out late Saturday afternoons. They'd come through with their guitars and sit out front. It wasn't no scheduled thing. Someone would come through with a guitar or harmonica. I don't know why they call these kind of places juke houses, though. A juke house was where anything goes. You got one room. No police, no license. Everything was illegal. The property was usually on a plantation, and the plantation owner didn't allow anyone to bother you. 'Y'all worked hard all the week; go over to so-and-so's house and have a good time. Just don't hurt one another.'

"My mother and father at one time pretty much ran a juke house. That's how they ended up down here. Had a little old small house in the front yard. As a matter of fact, the place where Henry Stuckey was living when he moved out in this community was a place that my father used to have as a juke house. When my father came here to this place, he rented a juke house to Henry Stuckey to live in. It had two rooms, a pool table, a jukebox, a place to cook—right in the front yard. In other words, my mother could come out of the house where we actually lived and go to the back door of the juke house. She would sometimes prepare meals at the juke house and bring them to us at the living quarters or prepare food at the living quarters to sell to her customers at the juke house. The big things back then was chitlins, hot dogs and buffalo fish. That was the main courses at the juke house. Main thing was playing that music and serving the moonshine whiskey. That's where they made their money on Saturdays."

The Devil's Music?

"See the same faces on Saturday night, see them Sunday. Does that make them sinful? I don't think so. If you decide that you want to tell about a personal experience you had in life, that's good. People use the church to testify all the time: 'I'm praying for God to give me a job,' 'praying for God to heal my child.' Now, you stick a guitar to it, and 'oh no, oh no!' Some of the same lyrics that Jack, Skip, Muddy…Some of the same lyrics are spoken in the church, but you put a guitar to it, it's the devil's music. That part I don't understand. People frowned on you telling a story with music to it, putting your emotion in it. Start crying, singing, 'My wife left me' or 'I'm broke' and start playing the guitar, then all the sudden that's the devil's music. When did they decide that they wanted to separate that? 'This is OK because there's no music to it,' or, 'That's not acceptable because it's got a guitar part.' Any preacher can listen to you tell your life history, but you start putting a blues guitar to it, and he don't want to hear it. My thing is if God bless you with a particular gift and if you don't use it, he takes it away from you. Anything an individual does, if God is glorified in it in any way, he's satisfied as long as what you're doing don't take your relationship with him away."

The Bentonia School of Blues

"Henry Stuckey was my neighbor in 1957. At that particular time, he had an old acoustic guitar seemed about ten feet long, 'cause I was a little kid. He

played almost every Saturday night. I got my first guitar in 1957 after seeing Henry play, but I wasn't influenced by him. Most of my influence came from Jack Owens. My mom and a lot of elderly people, they say that Henry Stuckey started the Bentonia-style blues, and Skip and Jack picked it up. Jack even said that. It's my understanding, according to Jack, that Henry Stuckey started playing in that style, and [Jack] said, 'I want to play like him.' He said Henry started that style of music and then along came Skip and along came Jack.

"Now, if there's ever been a man who was determined for someone to learn what he knew, it was Jack. Jack was determined that I learn Bentonia-style blues. Why he was so determined, I don't know. He said, 'Boy, somebody's got to learn this.' He said, 'The first thing you got to learn to do is to learn how to play this thing in open E [tuning].' What he called a 'cross note.' He said, 'Boy, when you learn how to play that in this tune it's gonna sound different than anything you ever heard.' And that's exactly right. I don't care how you tune it, it don't sound like the way Jack played it. It's almost like it plays itself. He'd say, 'What you do is when I shake my head, you fret it.' And he'd be playing 'The Devil' or 'Catfish' and shake his head. And it got to the point I could play right along with him. 'Boy, you catchin' it. You keep on. You gonna get it.' It was hard learning, man."

The Hardcore Blues

"I've always loved blues. Strange enough, as famous and popular as B.B. King was, he only had about a couple songs that I really liked. I admire him for what he did. My thing is that you can't do something different. I like it when I know who's playing that guitar without even seeing him. Right now, you know who it is. You've got any number of people who can play the same style of music, but you wouldn't have to see him and you know it's B.B. King—or is that somebody else, because a lot of people can do that? But when you hear a CD or whatever of Jack, you know right away that's Jack Owens. Like even Albert King, if Stevie Ray Vaughan didn't sing, and you just hear the music, you thought it was Albert King playing, 'cause he played just like him. Jack, Skip and Henry, you know right away. Muddy Waters, you know right away. Lightnin' Hopkins, you know right away. A lot of people try to duplicate it, but it couldn't be done. Lightnin' played a real simple style of music, but the way he did it was with a lot of personal feelings. Like I say, I've always loved hardcore blues. Even today. I never spent a dime on a B.B. King tape. I think I may have bought one of Albert. Muddy Waters, John Lee Hooker, Howlin' Wolf, I used to have them by the pile.

The Interviews

"I seen Howlin' Wolf once in Yazoo City years ago. A place called Silver Slipper. When he got up on that stage, shoot! Look, he lost it! He done lost it. When he got up and got that harmonica, he took the roof off the building. He had that blues in him. Yes, sir.

"In those days, when it came to country blues, hardcore blues, no two people played alike. I'll tell you why: blues is like your relationship with Christ. It's personal. What drives me to sing the blues don't drive you. My emotions—things I talk about in a song, things that drive me to sing—ain't the same things that drive you. It can't be the same.

"They say Skip James and Jack Owens played the same. Well, they might sound the same, but the conditions that Jack had in his house were not the same as the conditions Skip had. Muddy Waters, Howlin' Wolf, Lightnin' Hopkins—all those guys was fueled by different things. They'd sing the blues because of things they probably had at home: money, women. The same thing that fuels me don't fuel you. That's country blues. I'm not talking about urban blues, you know, where you might look at what people sing because that's what the audience wants to hear. The kind of blues Jack and Skip played wasn't for entertainment. It was to tell a story, and most of the time it was true. Later on, some people took it for entertainment."

Keeping the Blues Alive

"I went out to L.A. back in 1979, and this guy came down the street. Black guy. We was sitting back in the walkway on a Saturday morning just drinking beer. And this guy come up and said, 'If you guys give me one of them beers, I'll play this guitar for you.' Looked like a bum, but he had this old guitar. Look, man, we gave him a beer, and you talk about playing the blues? Aw, yeah! Guys like these would always go from community to community and play their guitars. Drinking beer and playing the blues. He played hardcore blues like Muddy and them, but he didn't play in no open E or E minor. He played just an old standard-type deal, but he put himself into it a whole lot. I remember he did a couple songs that Chuck Berry recorded, but he did it from a blues standpoint. Like, 'Well oh well, I feel so good today,' but he did it from a blues standpoint. He acknowledged that Chuck Berry made the song, but he was going to show us how it was supposed to be done. I was already playing but had kind of got away from it. I came back home in November '79, bought another guitar, and from that day, I been back into it deep ever since. I could play, but something about what that guy did when I was out in L.A. inspired me. Somehow

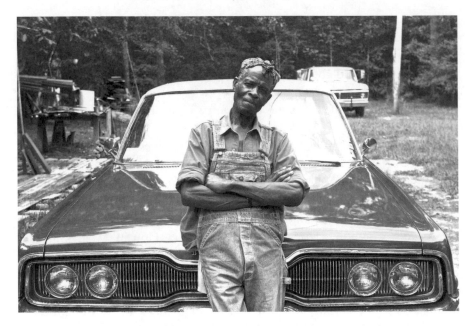

L.C. Ulmer relaxes on his classic car near his home (Ellisville, Mississippi, 2009).

what I seen that guy do, combined with what Jack had been trying to get me to do, I just got back into it.

"Right now, black people don't like to be identified with the blues. Not country blues. Now, they're OK with Little Milton, B.B. King, Bobby Rush, Albert King, but when you get down to where you really, really tell it like it is, then some say it takes them back fifty or sixty years ago to when black folks in the Deep South were having a hard time. But then, look at the history book. They haven't thrown away the history book! The history book tells it all.

"I think I owe it to guys like Jack Owens. I owe it to them to try to perpetuate what they started. 'Cause otherwise it's going to get lost in time, other than picking up a CD or cassette or reading an article. You'd never actually see anyone really playing the type music that I want to. I credit Jack. He decided he wanted to leave it with someone."

L.C. ULMER

At the end of the movie *M for Mississippi*, a smiling elderly man dispenses deep blues and sound advice. His confidence and talent are a perfect fit for

the big screen because L.C. Ulmer is a superstar, even if few others know it (yet). Currently, he has one CD available, and another on the way, from Hill Country Records (http://www.hillcountryrecords.com).

Playing from the Hard Core

"I was born August 28, 1928, in Stringer, Mississippi. Learned how to play a guitar in that area and around Moss Hill. After that, I got to moving around and learning things from other people on my own.

"My daddy made us all work in the field. He said, 'If you work, you're going to take care of yourself.' He said, 'I'm the grownest man in this house, remember that. When you get married, you ain't coming back here.' All fourteen of us got married, and none of us ever went back home. Seven brothers, seven girls.

"He was a blues player, and everybody that stayed around us in that settlement was blues players. And they would all get up under the porch [for some] old Christian singing every evening when they come out of the field. They would sit up on the porch with their britches legs rolled up high, and they would sing till twelve or one o'clock at night. They'd be playing guitar, maybe a banjo, a fiddle, harps. They didn't get no money for it. Next night, they'd do the same thing all over again. Somebody must have heard it one day and seen there was money in it. They went to getting these people out to cut records. That's how it got spread.

"I know so many blues that it'd take me twenty years to play them. I can lay my guitar down [on my lap] and play it all night long with the slide or either with a pocketknife or either with a pencil. That's all they had to do after they come out of the field. They'd get up, and sometimes the whole family would come to your house. Family would come and start to cooking other folks' corn. Y'all just went over there. Man, you'd be in the middle of a big singing session. Some folks sang church songs. Some folks sang the blues. People began to come and listen, big-shot people who had money would tell these guys about what they could make. And these guys would go try it, like Muddy Waters, and Robert Johnson, B.B. King and all them other guys, John Lee Hooker, Tampa Red.

"They played the guitar the old kind of way, and there ain't too many folks who know the old kind of way to play a guitar. But I know the old-timey sound. My first song I really learned how to play [was] 'I wore my .44 so long till made my shoulder sore.' And folks commence to paying me from that. Walking down the street. Nickels and dimes. I was just about

eleven years old. I started to playing when I was nine and a half. I got my first guitar and tore it up, 'cause it wouldn't play right. I got me another one. That one played right. That won me a lot of girls. Now, I know I got to play now. There was a song out don't nobody sing now: 'If you want you a woman, better keep her by your side/'Cause if she flag my train, I'm sure going to let her ride.' That's way back in the '30s. You don't hear nobody playing them now, but I know every one of them. I can go back and play some blues by Blind Boy Fuller, Blind Lemon, Tampa Red, Peetie Wheatstraw. We had all them records.

"These new guitar pickers can't pick it up 'cause they don't go back far enough. They got beats in music not supposed to be in there. They got all this foot pedal work. That's not the hard core of playing a guitar. Robert Johnson and them played from the core. You know what the core is? You see a seed come up. Come out of the ground, didn't it? Then it matures. To me, that's the way music is. It didn't have all that other…you know, all this hooking up, and you put your feet on, changing that to that. Well, that's putting something to your blues that didn't come out with it. Play me a natural guitar. I'm talking picking a guitar. I'm not talking about strumming it. They picked guitars when I was coming up. You want me to give it to you straight? Muddy Waters, John Lee Hooker. And before B.B. King got that style he has, he was playing it. He used to come to town all ragged and dirty with his knees out, out of that cotton field. He was playing all the strings then.

"Now, Jimmy Reed, he played a hardcore guitar. That's what you want. Ain't many folks can do that. They can play. I ain't downing nobody. Their way is their way. But when I play, my guitar sound just like the day I started to playing. I'm playing in the old-timey key. That key was before I was born. Robert Johnson had it. He was at one time the outstanding-est guitar player in the world, besides one man: Blind Lemon Jefferson. No man in the United States ever played a guitar like him. I've heard his records time after time. My daddy seen him. There was another player they called Jimmie Rodgers out of Meridian[, Mississippi]. He sat on my daddy's porch all the time and played while he drank whiskey. He loved to drink, and he used to come by time after time. And a lot of folks don't know his chords, not today.

"You know those old records you had one song on them but they were big [78s]? Those records were played from the hard core. One guitar, most of the time. Well, what was they playing from? They was playing from the hard core of the way they come up out of the cotton field. Every evening folks get together and set from porch to porch, time to time, and they would sing

different songs. That's how people learnt. They would have them old-timey, breakdown fish fries start on Friday night. They would start them fish fries on Friday, twelve o'clock, frying them in a wash pot. And they would run that fish fry Friday, Saturday, Sunday night till eleven o'clock. Folks would dance and gamble all that time. Down in the house, out on the porch or in the yard. Somebody wants to give an old breakdown here and knows how to give it. When that fish come out of that wash pot, you couldn't get enough of it. They put the fixings with it and everything. The more you get, the more you want. And then they would have different types of cakes made from scratch. Then they would have these here apple pies, peach pie, peach cobbler, chicken and dumplings—made from scratch! I ain't talking about bought-made stuff. I'm talking about cooked on the wood stove. I'm going on back there when people cooked.

"And then you hear that music? They would drink and dance all day and wouldn't nobody be drunk. They'd go cut logs. If you was in the logger woods, you could hear a guy hollering, 'If you see my milk cow/Please drive her home for me.' Now, how many people you hear singing that song? You'd hear folks singing, man, all kind of blues in the field. They kept themselves in a [good] spirit. That's all they had."

More Women Than a Train Can Hold

"My father learned guitar from his father and mother, both. Blues was all there was. It started in the cotton fields. Ever since they built a cotton field in the state of Mississippi, the blues started there. Now, I can play all over the guitar, 'cause I played too many jukes by myself. Didn't need nobody to help me. I can play piano, guitar, bass, harp, organ, mandolin. I can play a fiddle and a banjo. I picked all that up through the years. But I'll tell you: I didn't care nothing about playing guitar.

"Now, I'm going to tell you the history of that. I'm going to school. You know you going to try to have you a pretty girl in school. You laughing, 'cause that was your thought, too! Man, I had me a pretty girl in them years. So there was a hard guitar picker to come out of town, out there every night. They'd break school, and he'd play for all the dances. That's the reason I know so many dances: the Suzy-Q, the Big Apple, Break the Chicken Neck. They break the school for summer. All the kids had a part to play [at the final dance]. Me and my girlfriend had a part to play in dancing. Everybody who had a girlfriend had to see who was going to be the best. Man, that hard guitar player came out there that night. I was playing at that time, but

I couldn't play nothing. Ain't no use in me lying about it. That guy playing that night? Me and that girl beat the house dancing to him. But when we got through dancing, she told me, said, 'Now, when you learn to play a guitar like him, you can get me back.' That hurt me. I said, 'You've got to be kidding.' [She said] 'I love music, and you can't play that good.'

"I went home, and you talk about practicing. Mister, I practiced so hard before the next semester of school started. When it got time, one of the teachers said, 'Mr. Ulmer, you ready to play guitar for our school semester [break]?' I said, 'Yes, ma'am.' I played that night. They out there dancing, people was everywhere. Woo! Like ants on a mule skin. [My old girlfriend] looked. She said, 'Now you can get me back.' I said, 'Sorry, lady. I don't need you now. I'm going to get more women than a passenger train can hold.' And I wasn't joking, either. I said, 'I'm going to buy me a brand new V-8 Ford. And the prettiest woman you ever seen going to be in that Ford right side of me.' She wanted me back, but I didn't go back. I told her, 'I'm going to get me as many women now as a passenger train.' And I meant that.

"I was in every state you can name. My first big stop that started it out? With the guitar, getting on the air? Holbrook, Arizona. I played with Fats Domino there. They had a Cock & Bull [bar], and I'd come up every week and play there. Les Paul and Mary Ford played there. See, I was a janitor at this place. This was a big place, and I worked there. Call them. They'll tell you.

"Elvis Presley come there. That's where I met him. Oh, they told him, 'We got a man here who can do your dance and play what you play.' They told him, 'That man will put that guitar up behind his neck and sit there and play it all day, and then he'll sit down on it and ride it and play it.' I did in them days. I had me an old big guitar. And I got him there, and I said, 'Elvis, sorry, but I'm going to show you something about your music.' He picked it all up from colored folks. I know the man that learned him, Arthur 'Big Boy' Crudup. He said, 'You don't know the man who learnt me.' I said, 'Yes, I do. He was a fox-hunting man. He put out that record about "I got my questionnaire, and they need me in the war."' He said, 'Yeah!' I said, 'He the one who caused you and B.B. King to be where y'all is today.'"

ROBERT "BILBO" WALKER

In his seventies now, Robert "Bilbo" Walker is an absolute throwback to another time and place. On a good night, Walker will pack the house at a Delta juke joint. Decked out in a flashy suit and signature wig, he'll dance

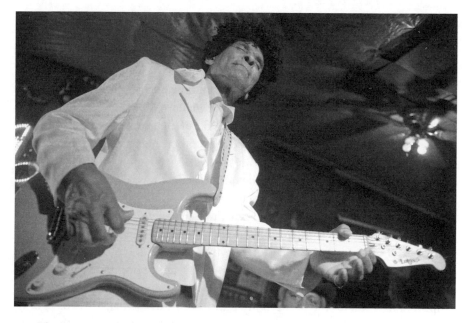

Robert "Bilbo" Walker performing at Reds Lounge juke joint (Clarksdale, Mississippi, 2009).

with his guitar, duck walk across the stage and freely mix Muddy Waters, Chuck Berry, Sam Cooke and Loretta Lynn. Recently, *Ebony* magazine featured him in an article about Delta blues. Upon seeing the issue, he commented, "Everyone's making money off me but me!"

Humble Beginnings

"My name is Robert 'Bilbo' Walker. I was born off New Africa Road [in Clarksdale, Mississippi] on Kline's Plantation, February 19, 1937. Seventeen [children] in the family. We picked cotton. Picking cotton and chopping cotton—that was a good life then. When you compare it to some of the things you go through now, it was good. Actually, when you compare the prices of everything, it's almost just as good as it is now, 'cause what we could do with $15 a week there, we need $500 now to do. That's right. $500 won't compare with what we could do with $15 a week there.

"Physically, the work was hard, because everything was done from muscles: cutting wood, sawing wood, picking the cotton, and carrying the cotton to the scales. There was a lot of work in everything you did back in those days, but it was enough to keep people busy and out of trouble.

"The first music I ever heard was when I was a little boy and the radio first came out. People were so anxious to hear a radio in those days. About ten o'clock that night, Daddy rigged up a piece of wire on what we call a poking iron—what you stir the fire with—and the radio came on. The first thing we heard come on was [singing cowboy] Slim Rinehart. The next music we were able to hear on the radio—that's before the B.B. Kings or any of that stuff, you know—was Ernest Tubb, Roy Acuff and a few others. That's what I first started to singing. I'd get around the house and sing like those guys. But you couldn't sing it around white people, 'cause they were white and you were black.

"I'd get under the house and stretch me out a little piece of baling wire from one chimney to the other, and one day I learned that if I would tighten that wire, then it would make a noise. So, in the next couple days, I went outside and nailed me a nail up in the tree. I went down and stretched it down to the bottom and nailed it. But it wasn't tight enough, so I went and got a great old piece of iron and put up under it, and that really tightened it up. Then I took an old snuff bottle, and I'd hit the string. I started going up and down that thing getting a song, and then I'd start singing—the music never was with the singing—but I learned to keep a beat with that thing."

Gospel Turns to Blues

Walker moved to Chicago around 1954. He sang gospel until a fateful event changed his life.

"In Chicago, I met a boy called Little Monroe [Jones]. That's the man that caused me really being in the blues today, in a spite way. Trying to get even with somebody is the cause of me being in the blues. Little Monroe used to come up to the house when I was living up there on Fourteenth Street, right next to Maxwell Street. He'd keep me woke half of the night, learning him how to play Jimmy Reed, 'cause I could play Jimmy Reed backwards. I wasn't so interested in blues; I was more interested in gospel.

"So he'd sit up there all night. Sometimes he'd bring me four dollars, five dollars just to keep me woke, 'cause I always kept good equipment and he didn't have no guitar. And I learned him how to play Jimmy Reed, a few Muddy Waters and Little Walters. Learned him how to play it, and I stopped. I told Little Monroe, I said that I really ain't got time every day, 'cause I was driving trucks. I ain't got time to be staying up all night, and I don't really like no blues, anyway. So he vanished on off.

"It wasn't no more than six months later, Little Buddy Thomas, a friend of mine who was playing guitar, came by. He said, 'Robert, you want to go

with me tonight to the Cotton Club? I got to go carry Little Monroe my guitar and amplifier. We ought to go over there and he'll let us do a number.' I said, 'He'll let us do a number? I'll bet he'll let us do a number. He'll probably want me to back him up.' He said, 'I don't know, but he said to try to get you to come over there if you would.'

"We went on over there, and I'm sitting there waiting for Monroe to come out. The band came out and played for a while, waiting on Monroe. It was about 9:30. No Monroe. I told Buddy, 'Let's go, man. He ain't going to show up.' He said, 'Monroe's already here. Just wait for him. He's real good.' I said, 'Oh man, I done heard the mess he plays, 'cause I taught it to him.' So, directly, Monroe comes out, and Buddy says, 'We got Robert Walker over here tonight.' Monroe looked over, he shook my hand, and we talked a while. He said, 'Will you come and do a number for me tonight?' I said, 'Yeah, I'll do one or two for you.'

"So he got up there and played a couple of numbers. Then he introduced me to the people. He said, 'We going to bring him up a little later in the show. Everybody thinks I'm the greatest, but I'm going to introduce you to the greatest man that ever picked up a guitar. This man taught me. This man knows guitar backwards.' I'm smiling, 'cause I'm thinking he's smart 'cause he ain't played nothing but a couple Jimmy Reeds and maybe one Muddy Waters. I heard him introduce me to the people, and the people went to clapping and wanted to hear me, 'cause if I done taught him—they already knew what he could do, but I didn't—then I got to be good.

"B.B. King had just brought out with 'Sweet Sixteen.' Nobody else is playing that but B.B. King, and the world is really being rocked. Man, that Monroe reached back and got 'Sweet Sixteen,' and when he got through playing, there wasn't a woman in there sitting down. He was making it sound so much like B.B. King that, if you were standing outside, you'd say B.B. King was here. So I'm sitting there, and my heart's pounding fast because the little guy I taught [seemed to] learn all of this overnight. Then Monroe played a couple other really bad numbers. Then he got up and said, 'Get ready for the treat of your life. Let's call the one and only Robert Walker, the man who taught me.'

"Well, I drew up in the corner and didn't want to go. They said, 'There he is. Get him up.' When I went to get the guitar, [Monroe] walked over and turned his back to me to talk to Buddy and laughed, knowing I didn't have what it took to go up against him. Even the stuff I could play, didn't nothing come out right. I played one of Jimmy Reed, and the folks just stood there and looked at me. I played one of Muddy Waters. The folks waiting on me to bring

it on, [but] I didn't have no more to bring. I put the guitar down and walked right out of the place and got in my car. I told my girlfriend, 'Let's go.' 'Uh, I'm going to stay. I want to hear him play some more.' He carried her home that night. That was another hurting thing. I went home. I cried all night."

Revenge Is Sweet

"I said, 'Now, what am I going to do to get him back besides finding him and beating him half to death?' So that Wednesday, I went and bought me a brand new guitar. You know the Silvertone with the three pickups? It just had come out. I wanted a guitar that [Monroe] wasn't playing and Buddy didn't have. I said, 'I'm ready.' I quit my [day] job. I said, 'I got to work on this.' I laid around there, and I was playing, and I finally got a few of the blues like I wanted. And I made up a couple of songs. That's when I put out, 'I been down so long, but I'm on my way back up again.' That sounded good to me. My mama said, 'Oh, that is real pretty.' I said, 'Yes, but it's slow. It ain't got what it's going to take to go up against this boy.'

"So I went back home that night, and I thought about Chuck Berry. I said, 'Chuck Berry was on TV the other night.' I said, 'If I could get him down, I'd put on one of his suits, and I'd have something to go against [Monroe]— something ain't nobody playing except for Chuck Berry.' I got up there, and I couldn't get it right. I lay up in the bed and twist and turn at night, but like in a dream, if you lay there and doze off to sleep with music on your mind, it'll come to you. And it come to me.

"That was nothing but hatred, man, but I wanted him bad. I'm walking around in a daze, almost like a man on drugs. That's how bad it was.

"So I got up and I started doing [Berry's stage moves] without the guitar. After about two hours, I had the step real good, going out there dancing. Then I started doing the guitar, and I finally got it so I could sing. But that wasn't good enough for Robert Walker. I knew Chuck Berry could go out there, whirl around and go back, but he never could dance backwards like he went out there. So I started doing it backwards. You know, I wasn't intending to—it was just something that came to me, so I started practicing. You know, they got a long cord then. You ain't got time to look back to see how long your cord is. You got to practice how many steps you can go out and then go back. I would go out there to the end of that cord, and I could feel it. I would know it, and I would stop, and I would dance backwards.

"When I did my song, 'I been down so long, but I'm on my way back up again,' that got everyone's attention because that hadn't never been did.

Magic Sam hadn't bought it from me and recorded yet. It had never been heard before, so the people started looking. People started to whispering and started to standing up. Boy, when I got on that Chuck Berry song, there were too many people, so the barman got up on top of the counter and couldn't serve the people. I said, 'Well, I've got this bastard now!'

"Boy, I went across that stage, and I did it better that night than I had ever done it. I went out there, and I'll bet you I did it eight or nine times. And when I stopped, the people shouted, 'Robert Walker! We want Robert!' I wanted to sit down and get the sweat off me, and the owner came over to me and said, 'I'll give you twenty-five dollars if you'll do that one number. I said, 'OK, I'll do it.' They put a little tip thing out there for the people, and they put about seventy dollars in the tip thing. Monroe sure enough looked like a fool.

"When I was doing it the second time, he got up there and was looking at my hands. When he got to the mike, he said, 'I told y'all he was the greatest that ever lived. See, the last time he was here, he was trying to protect me, 'cause he taught me. But anytime you on my show, I want the man to show you all what he can do.' I'd done shown him up, but he just wanted to make himself look good."

THE MISSISSIPPI MARVEL

To music fans around the world, the blues is something of a religion. To many older Mississippians, however, it's still the devil's music—the opposite of church songs.

"The Mississippi Marvel" is an eighty-year-old bluesman who also plays gospel music and preaches in a very traditional church. When Broke & Hungry Records' Jeff Konkel approached him to record a blues album in 2007, the deacon at first declined until Konkel promised to keep his identity a secret. The agreement continued for Marvel's "appearance" in *M for Mississippi* and is still in effect today.

Eighty Years of Living the Blues

"I was born in 1930. [From] where this house is sitting, I was raised on down this road, about a mile off it back down in a wooded area. My parents farmed. At that time, it was cotton. There ain't no farming now.

"My uncle made a guitar out of a cigar box; they called him 'Kid,' but his name was Taylor. He went from there to what y'all call a 'stick' [an acoustic

guitar]. He learned me how to play the blues. There was another guy, named Harris—now, he could sing and play the blues. I learned a lot from him, too. My uncle and me didn't never play in no clubs. We played for open house parties. Sometimes we played for nothing but a drink of corn whiskey.

"But then, after I got up to be a pretty good size, I didn't even fool with a guitar except every now and then. After I went into the military service in 1950, I wouldn't even pick a guitar up. Korea—that's where I was for about fourteen months. I spent most of my time there in the regular army. And after I got out and come back home, it was a long time before I fooled with a guitar. My uncle got me started again. And I started playing with him, mostly playing a stick. It was a while before we came across an electric guitar.

"After I got out of the service, I was big enough then to go around to the juke joints and juke houses and things. We were playing old songs. We used to have a song about 'Black Mattie's face gonna shine like the sun/Lipstick and powder don't help her none.' Oh, we used to do all them old, down-home blues. That's [still] all I ever do—hard blues. At one time, I didn't even have a guitar. But I got a hold of a guitar from one of my stepsons. That's it in there [in the bedroom] now, the old guitar."

Remembering the Old Bluesmen

"Sonny Boy Williamson [II], now, y'all ever heard of him? He used to play around here. I saw him. He could put on a good show. And he used to come on the radio. He'd announce where he was going to be playing. Sonny Boy had feet about like that [shows oversized length]. He didn't need no drums, you know, on that wooden floor. [Laughs.] He could make it sound like drums with his feet. He used to be at this little place called the Greasy Spoon. He put on shows over there by himself. I do 'Nine Below Zero.' He did that.

"I moved to St. Louis in the last of '69. I used to go to East St. Louis. I went over there to see Albert King. I believe I also saw Elmore James there. [I played blues up there] now and then at the house. I mostly worked nights, but when I'd be off, I'd sit up all night and listen at Muddy Waters [records]. I've got near about everything he ever put out on 45s and 78s. I didn't get to see Muddy Waters live, but I'll tell you who I did get to see live: Howlin' Wolf. It was just before he died. He was up at Chuck Berry's farm [in Wentzville, Missouri, near St. Louis]. Man, look, he got sick, and they carried him back in that room. But when he came back out, he had everybody dancing. Oh, yeah. They was dancing, you know, and he let them dance a while. He died shortly after that.

"Before I moved to St. Louis, I worked at [a chemical plant] for about five years. And before that, I was a tractor driver on a plantation. I was always right around this area. Look, that's where a lot of blues come from, is out of the fields. That's where Muddy Waters' blues come from. I didn't know too much about B.B. King, but I know Muddy Waters and Howlin' Wolf—that's where they sang their blues from. Like hoeing, chopping cotton, plowing [with] a mule. Hard work.

"[We sang] all the time, yeah. I remember a boy who used to drive a tractor out on [the plantation]. He would sing—he had a good voice. We was down, way back in the woods, in a bottom down there. You know those old John Deere tractors? 'Pop, pop, pop.' I cut my tractor off for something—I guess to get a drink of water—and I heard him over there, man. He had parked that tractor [and was singing], 'Chain, chain, chain.' He was singing 'Chain of Fools.' And he sang himself into a preacher. He's preaching now."

Church Music Came from Blues

"Well, now, they tell me that church music, it came from the blues. So I was told. See, I play for church now. But you play, and you still got your blues rhythm of music, but you sing a church song. I play guitar and sing in the church. The most average artist that put out a church song, they did blues first. They did blues before they did church songs. Aretha Franklin, she did blues. A whole lot of them did blues. But some people don't like it. Well, you know the reason I didn't want my name out there too much [as a blues musician] is that I'm a deacon of the church, you see. Sometimes you ain't supposed to let your right hand know what your left hand is doing. [Laughs.]

"Blues is a good thing. It helps [people] most of all 'cause they get paid for it. A lot of the reason that some church people were in the blues field was for the money, you see. You feel a little different when it's gospel music, 'cause you've got a different spirit going with you there. I love blues. But playing the blues…It ain't that there's that much wrong with it because you're in the church, it's just the position of the people up in the church—the deacon or something. See, as far as they're concerned, if they want [a deacon] to play in the church, he better not bring his blues down there. Now, a lot of churches don't want you to bring a guitar in there, but they've got a piano. What's the difference? It's music. But the Bible tells you to make a 'joyful noise' with your instrument. Now, that's just really coming down to the point. What is the blues? When God said make a loud noise with your instrument, he didn't tell you [not] to sing, 'Baby, please don't go' or nothing

like that. He just said, 'Make a loud noise with your instrument.' And the Bible says when they're making a loud noise with their instrument, they're singing, 'Hallelujah, hallelujah.' It didn't say what instrument."

"I've got to play at church tomorrow," the Marvel says. With that, he picks up his guitar and launches into a spirited example of a church song based on the traditional "Ain't That Good News." When he's done, Konkel, his producer, comments, "I'll tell you what: you've got better music in your church than I do in mine!" Everyone laughs. Feeling the spirit, the Marvel leads into another tough old gospel number: "What is this, makes me feel so good right now?"

Blues Is Here to Stay

"Blues will never go away. Blues is here to stay. See, it's coming back now. Y'all are bringing it back. It ain't going nowhere. The blues is different than it used to be, now, because you got all this rap and rock and stuff going on. But what y'all are doing now is a good thing—digging back up dead blues, you know. As the old blues come back up, [younger musicians] are trying to play it. The blues is like dope. Dope is here to stay. The blues is here to stay."

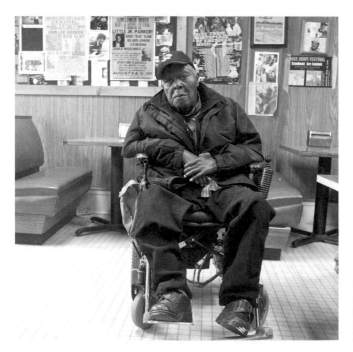

CeDell Davis during an interview at Sarah's Kitchen (Clarksdale, Mississippi, 2010).

Ellis "CeDell" Davis

The comeback. The rediscovery. Son House, Bukka White, Mississippi John Hurt, Skip James. Blues music has a rich history of such rebounds.

The latest name on the list? Eighty-something Cedell Davis, brought back to blues life by a band called Brethren. Like the wheelchair-bound Davis, three of Brethren's four members have debilitating health challenges, a fact that is not lost on the band's guitarist Greg "Big Papa" Binns.

Contemplating his own retirement from music due to psoriatic arthritis, Binns sought out his blues hero at a Pine Bluff, Arkansas nursing home and found inspiration. "Nothing stops this guy! I said, 'He needs to be back on the stage.'"

Davis did just that when he returned to the stage at the 2009 Juke Joint Festival in Clarksdale.

Born in Arkansas, Raised in Mississippi

"I was born in Helena, Arkansas [on June 9, 1927]. My full name is Ellis Davis. My nickname is Cedell Davis. I had two brothers and a sister on my father's side. My mother didn't have but two children. That was me and my half brother.

"My stepfather worked in West Helena. But I didn't hardly live with him and my mother. I lived with a cousin of mine in Mississippi. Right outside of Tunica—what they call Clayton. The juke joints have always been around Tunica, but when I was playing there, they didn't have casinos. Now, they have sixteen. There was plenty of gambling going on in the juke joints, though."

The First Guitar I Ever Heard

"Blues was the first music I remember hearing. The first guitar I heard played was James Crump. After that, it was Jake Douglas. Then, I heard a fellow who used to come through the farms, playing guitar and blowing harp. One day, my cousin sent me to the pea patch to pick some peas, and I found a harmonica. I started blowing on it, and that helped me out a little. Later, I went to [bluesman] Dr. Ross's house. We called him Ike. He played a harmonica, but I went around side the house and seen this long strand of wire with snuff bottles in it. They called it an African diddley bo. Well, I went home and made me one, so I started playing on that thing.

"This fellow who lived between Helena and West Helena had two guitars. He got sick and was going to his people's to live. He sold me the guitar for two dollars and a half. I kept that guitar about twenty years. I just tore it up! That was acoustic. Wasn't no electric guitars at that time. I was ten years old.

"My mother didn't like me playing guitar. She didn't like blues. She said I'd go to hell. I'd go out on the woodpile and sit out there and play my guitar. Or either go to the restroom. She'd say, 'Get out of there!' That was the outhouse. [Later,] she said that's my talent and stopped bothering me. I was glad she did 'cause I was going to play anyway.

"I had polio when I was ten years old. I went to the children's hospital in Little Rock. I took two operations. See that mark on my hand? And the mark on my feet and ankles? They put what they call a 'plate' in there to keep it from falling all about—stabilize it. I stayed in the hospital two years and seven months. When I did come home, I went right back on the guitar. It took me a little while to learn it. I had kind of like a case knife—a butter knife, so to speak. Well, I developed playing with the handle of a case knife, and I played like that till I had this stroke, about three years ago. That stopped me from playing like that. Now, I just sing."

Nighthawk, Peck and Stackhouse

"I first met Robert Nighthawk when I was playing in West Helena. He asked me, 'Boy, what do [you] keep hanging around here for?' [Laughs.] You know, he was messing with me. 'Boy, you can't play nothing.' I said, 'I'm trying to learn how to play.' He knew what I was doing, but he was just messing with me. I said, 'I want to learn to play like you.' Well, about two years later, I come to him one day outside a radio station. 'Hey boy, here you is again. What are you doing here?' I said, 'I've come for a job.' 'You can't play nothing.' He's just messing with me, you know. He said, 'Well, come on and go around to the house with me.' I went around to his house, and everything he asked me to play, I played it. So, he said, 'Well, you can play. You're going to work with me Thursday night.'

"That Thursday night, I worked with him. Friday night I worked with him. He'd play lead, I'd play bass. I'd play lead, he'd play bass. That Saturday, [drummer] James Curtis—the one they called 'Peck'—he wanted me to play with him. I told him, 'Yeah, I'll play with you.' But then, Robert Nighthawk came by and stole me. He wanted me to play in Missouri with him. So, James Curtis came out Saturday looking for me, but I wasn't there 'cause

Robert Nighthawk had come down there and swiped me. So, I went on and played backwards and forwards after that. I'd play with Nighthawk for a while and Curtis for a while. Before I knew anything, they had me in front of the microphone, broadcasting [on KFFA's *King Biscuit Time*].

"Houston Stackhouse played with us sometimes, but he worked a day job most of the time. One time, some fellows got after Stackhouse—him and Robert Nighthawk. It was boys wanting to fight like boys do. Stackhouse tore out running [into the dark], but he didn't know a lake was there. Robert called him, said, 'Hey Stackhouse. Where are you at?' 'I'm way down here!' He'd done fell in the lake. And when he fell in the lake, his guitar got full of water. It wasn't no more good."

I Lived in St. Louis, Missouri

"I lived in St. Louis—the first time I didn't stay long—about three years. The next time I stayed five years before I come back. I went back to St. Louis in the last part of 1957 and the first part of '58. That's when I started playing with Trigger Slim. I [also] knowed Mary Johnson [Lonnie Johnson's wife], Charley Jordan, Dirty Red, Lindberg Sparks, Big Joe Turner, Little Milton, Ike Turner. Ike—he played with Robert Nighthawk a little before I did. Me and Robert went to his house one day in East St. Louis, and blood was all over the floor. I don't know if he had been fighting or what. He was a rough, tough guy, you know.

"I got trampled in East St. Louis. I was standing between the stage and the dance floor. Well, I didn't know they were fighting there. Some guy come up with a pistol, and they run over me. I was walking on crutches then, and they trampled me. 'Broke my legs, and I had to stay in the hospital for five months and six days on account of that. I walked on crutches again after that, but one of my legs was shorter than the other one then.

"Fights would break out back then. I remember playing for a guy out on a farm [in Arkansas]. I knowed the guy well that got shot, and I knowed the guy that shot him. The guy got stabbed on top of that. A guy called Geechie. He got shot and stabbed, and they thought he was dead. I thought about it, and I said, 'Well, feel his pulse.' A lot of them didn't even know what a pulse was, man. [Laughs.] I told them, 'In his arm.' They felt his arm and said, 'No, he ain't dead.' Next thing you know, the guy sat up. The fight was about another guy called Hop Along butting into his business."

Helena Could Accommodate You

"On a Saturday, all of the people from the surrounding areas would be in Helena. If you had the money, everything was there for you: gambling, numbers rackets, ladies. If you had the money, they could accommodate you. And there was music at just about every place. People played on the streets, too. First time I bought an electric guitar, man, I played on the streets, and I made fifteen or twenty dollars. You know, that was big money then. I wouldn't have hardly made that much at a club. At a club in them days, you may get six dollars, and you may not. You may get five dollars, and you may not. You may get something like three dollars or four dollars. Of course, back then you could take that dollar or two dollars and buy quite a bit of food. You can't now."

The Blues Is the Master of It All

"The blues is the master of it all. Today, not too many young people want to sing the blues. But see, blues is where all music comes from: rock, church music and all that stuff. A lot of people don't want to sing it, but you watch them. If you play blues around them, see what their foot do. Their foot goes to patting. Even if they don't say nothing, their feet be working."

MARK "MULE MAN" MASSEY

Mississippi State Penitentiary—better known as Parchman Farm.

For some seventy years, bluesmen have been singing about it—and with good reason. Even to this very day, there are musicians held behind its steely gates just south of Tutwiler, Mississippi.

Bukka White, Son House, Sonny Boy Williamson II, Leadbelly and even Elvis Presley's father all spent time there. In more recent years, Mississippi bluesmen like David Malone Kimbrough (Junior Kimbrough's son), Terry "Big T" Williams and the subject below, Mark "Mule Man" Massey, have continued this tough, unfortunate tradition.

Time at Parchman changes a man. It can be for the better, or it can be for the worse. In Massey's case, his harsh prison time informs, affects and fuels his blues. It's part of the reason he approaches his music like a man with a hellhound on this trail.

The Interviews

I Was Born in Clarksdale, Mississippi

"My full name is Mark Shannon Massey, and I was born in Clarksdale, Mississippi, in 1969. They call me the 'Mule Man' 'cause I sell and trade horses, mules, cattle, chicken. But mostly, I'm in love with my mules. The first couple years of my life, my dad had a job here in Clarksdale, and then, he was on the road a lot with Gulf Finance Company. He had a lot of the loans with the local juke joint guys here in Clarksdale. When I was born, we lived here a couple of years until we moved up the road to a community called Strayhorn near Senatobia, Mississippi. That's mainly where I grew up.

"The first music that I can probably remember would have been old country, and my dad was a huge blues guy who listened to a lot of your Howlin' Wolf, Muddy Waters and Lightnin' Hopkins. When my dad was riding the back roads and drinking beer, I would be in the back of the truck, and we would stop at these juke joints. I remember getting out of the truck, and he would force me into watching these blues guys play, which now I see there was a reason behind it all. My main influences are Mississippi blues and early country, like Jimmie Rodgers, who in my opinion was just a white version of a Robert Johnson. I believe that early country was really just the white man's blues. People automatically think that a lot of these white guys like my dad, because he was white, he had it made. But my family originally came out of Florence, Alabama. They were loggers that came into Mississippi and started sharecropping, living right beside the black sharecroppers. The only thing may have been that my grandfather could have been a straw boss, but besides that, there was no real difference.

"My dad and my mom sang and played music. Her and my dad had divorced when I was twelve or thirteen years old, and she had some habits, like drinking. My dad was trying to run a business and working his butt off, and I had a lot of free time. Idle time is the devil's workshop, and I was on the wrong side of the streets. My brother had gotten in trouble with the law. He was a musician and thought you had to do all these crazy drugs to be able to relate to what was going on. I just watched him mess himself up. He was thinking, 'I'm going to be a rock 'n' roll star some day.' And I was thinking, 'I don't know if this is the way you need to go, you know.' Later in life, he got on heroin.

"Like I say, everybody in my family played music, but I played football. Then when I got in trouble at twenty years old, running the streets and doing the things that I did, that put me in Parchman prison. That's when I lost my

football scholarship to Northwest Junior College. I had a good thing going, and I ruined it by trusting in buddies and letting my temper get the better end of me. Aggravated assault. I got eighteen years at twenty years old, and it was tough.

"Sittin' Over Here on Parchman Farm"

"When I got to Parchman, I lost thirty-six pounds in probably ninety days. It was attempted murder involving a family member. They were going to make an example of me, and they did. I was mad at the system, I was mad at God, I was mad at everybody. And three things happened right just before prison that were pretty weird. The shooting, and then two weeks later, I got hit by a train and totaled out a car and a boat I was pulling. Then, I totaled out another vehicle. So, I was on a route, man. I was gone. God grabbed me and said, 'I've got something for you.' Still, I was just so resentful toward him for so long. 'Why you putting me through this?' You're not supposed to ask that question, they say, but I was upset.

"As I met people in Parchman and got a job, I went through picking the cotton and the long line and maximum security and some of the roughest camps you can ever imagine—Camp 29, and all of the stuff.

"Finally, I earned my trustee pants, which gave me the opportunity to get a job in a warehouse at Parchman. That's where I worked and got married with my wife, and my son Luke was born. That was a tough time. My wife had our son on a Tuesday, got out of the hospital on a Thursday and brought him to see me on a Sunday. I got to hold him for two hours, and then they took him away. Two weeks later, I got to hold him for another two hours. It was really tough, but that's what I credit to keeping me straight when I got back out.

Join Together With the Band

"The Parchman prison band was where I learned to play. Before that, I had never really tried to sing except maybe at home during Christmas or something when everyone else was kind of playing. The main thing was getting an audition with a band. David Malone Kimbrough, bluesman Junior Kimbrough's son, was in the same camp that I was and in the Parchman band. He took interest in me, started listening to me sing and said, 'You might have something here. You may want to keep on playing.' And another guy worked with me on my country, and that's how I got in the band was

auditioning for by singing country music. I didn't play an instrument yet. I finally got an audition with the board members, these black ladies. One lady said, 'You're here to get into a band, but what do you do?' I said, 'I sing.' And she said, 'Well, sing.' I said, 'Ma'am?' She said, 'You want to get into the band?' I said, 'Yes, ma'am.' 'Then, you better start singing. Let's hear some of that country music.' I sang, 'Chasing that neon rainbow, I'm livin'…' She said, 'I'm for it!'

"Mr. [Wendell B.] Cannon ran the band. When I auditioned for him and got through singing, he said, 'Hell, I thought y'all said he could sing?!' [Laughs.] Boy, you know, he just crushed me. I'm in prison already. I don't need nobody knocking the heck out of me. But he said that because everybody was so egotistical that was in the band. He was just trying to knock the wind out of me. When I went in there, he said, 'Well, I'm thinking about…' He spit his Applejack tobacco. '…Getting you in here. What do you think?' I said, 'Mr. Cannon, I could lie to you and say that I've played for a bunch of damn people. I ain't played for nobody. But if you will teach me, I want to learn.' And that's all it took. He got me in the band, and [later,] I played for B.B. King with a stripe on my leg. Then, I met B.B. five years after I was release, and I said, 'Do you remember coming to Parchman prison?' He said, 'Yeah.' 'Well, I was one of the guys in Parchman when you came there. You'd just got your new black bus. You got out with a hoe and held up the light lines, so the bus could get through, and I was thinking, oh man, B.B. King's fixing to get electrocuted!' 'Yeah, I remember.' I said, 'We couldn't meet you, but you signed a picture and sent it over to us.' See, the minute after we got through playing, we had to leave. There wasn't no hanging around, hearing no other bands. Mr. Cannon was numb to the noise. He was like, 'Let's go. We done heard these sons of bitches a thousand times.' He didn't want to do no more shows, but he did them for us, so we could get out and see the free world."

"Oh Hell, I Done Left the Prison"

"We toured all over. Once, we even played for the Mississippi governor, Governor Fordice, when he was in office. That's when I called up my daddy and said, 'Hey dad, what're you doing?' 'Oh, nothing. What're you doing?' 'Oh, nothing.' We talked on for three or four minutes before my dad caught on and said, 'Hey, where are you at?'

"Usually the recorder says, 'Do not take any money orders. This is a call from the Mississippi State Correctional Facility.' Well, it didn't say anything

like that because the guard let me borrow the phone at the governor's office. See, my daddy didn't even know that I was trying out for the Parchman band, so he had no idea I got in. I was keeping it under wraps because I didn't really think that I could do it and didn't want to get embarrassed.

"I told dad, 'Oh hell, I done left down there at the prison.' He said, 'LEFT?!' I said, 'Yeah, I'm down here in Jackson. I'm at the governor's mansion. I snuck off from…' 'Mark, go back! GO BACK! You ain't got that long!' I said, 'They didn't treat me right, and I ain't going back.' 'No, man, NO!' I finally told him, 'No, daddy. I'm just playing with you. I auditioned for the Parchman band and got in.' 'What?' 'Yeah, I'm playing for the governor in just a little while.' That was a cool night, man."

"No Ice, No Meat, No Privacy"

"In prison, there was no ice, no meat. You take a shower and had no privacy. You're taking it beside all these other guys. But when you mess up, that's what you get, now. I ain't saying that I didn't probably deserve it, but dang—no air conditioning, dust all over your bed when you come in in the evening. You can't even have a TV or smoke down there now. The main thing was just the food. It was like slow starvation. It was just enough food to keep you alive, that soybean stuff that they were feeding you.

"It was just tough. There were a lot of guys that just didn't care. They'd been there for years and years. One guy that slept beside me had been there for fourteen years, and now, that's been seventeen years ago. And he's still there. The other guy beside me looked kind of like a Jeffrey Dahmer kind of guy, and he had cut a couple women's heads off. I ain't going to lie, man. It was rough. After ten years, they gave him a 'Christmas pass.' Back in them days, they'd give you a Christmas pass after you did good. But he went out and did two more. I mean, you're sleeping beside that guy and this guy right here. A lot of people, now, when they meet me, are like, 'Why's he a little bit paranoid?' Man, it's just a traumatizing situation that you went through—prison.

"When I first come home from prison, my wife was a nurse, and when she'd come home from work at one or two o'clock in the morning and tap my foot—you know, I'm home—but I'd jump straight up in the bed with fists cocked and all that. It took me years to get over that. It took four or five years to quit jumping, but now, you still have the dreams of being down there. I honestly believe the dreams. They're so lifelike that, when you wake up, you feel like they just have happened. That's what will keep a son of a

gun straight, man! I'm going to tell you what. When you have that kind of dream like I've had, you don't have to worry about no kind of rehab. If you had one dream and could see what I see when I'm dreaming...It was just a tough deal, man."

"Let Me Go. Never See Me Again"

"My uncle bought a glove factory to Parchman for the inmates to work in, and you think, 'Oh, well, that's going to get Massey out. He's got some clout.' Hell, no. I went up before the parole board, rode up there in a van with all these idiots at six-thirty in the morning. You can't imagine these idiots. I was thinking, 'Yeah, when you get out, you're going to come right back.' We went up there and stayed all day. A child molester was in there with me. He'd gotten all into the church and had a white T-shirt on with painted crosses on it, and he's in with the church chaplain and all this stuff. You know, they say the devil knows the Bible better than anybody, and I believe that. He rode the church coat sleeve and went up for parole and had all these letters. And here I am.

"My daddy did all he could do, and my uncle wrote them a letter saying that he'd give me a job, 'Mark's a good guy, blah blah blah. I said to myself, 'You know, I want to make it out. My wife's a nurse. We've got a kid. I ain't giving nobody no trouble. I'm in the band. Hell, I've got a good chance here.' No, man. These women were down each side, probably ten or twelve people total. I told my story about what had happened and the things that my brother had done, and what he had done to me physically—just the abuse that I had taken from him. He was on drugs and was my baby sitter. The women were crying around the table, you know. And I'm saying, 'All I want to do is go home. I've got a kid. My brother is up north in Detroit, now. I just want to go home.' They said, 'Step outside the door.'"

"When I came back in a few minutes later, they said, 'We found that you didn't do enough time for what you did, Mr. Massey, and we feel that you need to do the remaining fifteen more months at Parchman.' They asked if I had anything I wanted to say. I said, 'Yes. I have something I want to say. I want to thank God that I didn't get any more time than I got because you was damn sure going to make me do it.' I said, 'You don't know me, but I won't be back. You'll see. Once you ever let me go, you will never see me back down here again.' And I got up and walked out the door."

"I Want to Make Parchman Proud"

"To play blues, you have to go through some hard times, man. Everybody just thinks this blues deal is like, 'Hell, I'm a retired orthodontist, and now I'm going to pick up a harmonica, and I think my ass is going to play.' And that's what some people thought about me, at first, if they didn't know me. They'd see my baby face and say, 'What does he know? What credibility does he have here?' I got probably more than most, and I ain't near about through yet. You know? I'm still trying. I want to make Parchman proud of what they did to me. 'Hey buddy, you tried your damnedest to kill me and humiliate me, but I survived.'

"Lenny Steed is a guy down there in Indianola. He and guys like me and David Kimbrough are products of the Parchman prison band. Lenny came to my show the other night at Ground Zero Blues Club, and it was the first time I've seen him in eighteen years—since we were in the band together. It was emotional. It really was. Lenny, me and him, boy, we got to crying. He said, 'It's all right, Mark. We're free now.' I said, 'Yeah, boy, but it was tough. It was tough.' He said, 'Yeah, but you were young, and you made it. You made it.'"

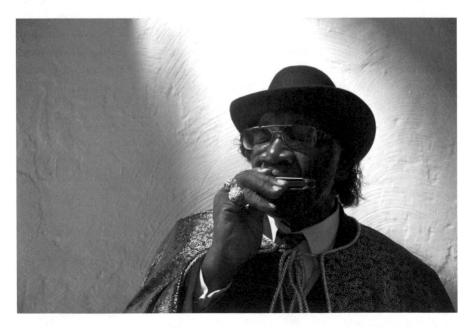

Mississippi's "Big" George Brock playing harmonica at home (St. Louis, Missouri, 2009).

"Big" George Brock: A Living Fossil Uncovered

"Big" George Brock. His life is the ultimate blues story. He picked cotton, boxed and played the blues in Mississippi. Then, like other bluesman of the era, Brock moved north in search of new opportunities. In his case, he didn't make it all the way to Chicago. He stopped in St. Louis where he opened a series of blues clubs and shared the stage with blues masters of the era. He's been married several times and fathered an amazing forty-two children. His brother-in-law is bluesman Big Jack Johnson, his nephew is James "Super Chikan" Johnson and his half brother is ex-ballplayer Lou Brock.

I first witnessed the raw blues power of Brock back in the mid-1990s at an urban juke joint in a tough part of St. Louis. Called Climmie's Western Inn, the club featured no cowboys and wasn't an inn. But the owner's name was Climmie. As I entered the old-school venue, I could hear the band running through a fast and frenzied blues instrumental. After a couple songs by the band, a series of bigger-than-life harmonica riffs came roaring through the bandstand's PA system, with no harp player in sight. Suddenly, everyone's attention was drawn toward to the basement stairwell, near the center of the club. Out of the downstairs ladies' restroom, up the steps and into the audience came a large man in a colorful three-piece suit and hat. From that moment on, Big George Brock had both his cordless mic and the audience in the palm of his hand. Muddy Waters, Howlin' Wolf, Jimmy Reed, Sonny Boy Williamson II, B.B. King: he conjured up their sounds and a little of their souls that night.

Most of this feature comes from an article I wrote for the UK's *Blues & Rhythm* magazine (http://www.bluesandrhythm.co.uk) in 2005.

Early Years in Mississippi

Born near Grenada, Mississippi, on May 16, 1932, Brock developed an early interest in blues. According to Brock, "When I first heard blues, my uncle was singing that song, 'He got a coal black mare, oh how that horse can run.' That's when I first knowed anything about blues. That was out from Grenada. I was a little boy then. He used to have a horse that he'd ride and come down, and you could hear that piece coming down the road. My mom and dad used to get up and go out on the porch and hear him sing, and I did too. I thought, my god, that man into something! Then, as I growed up, my daddy bought me and my brothers each a harmonica. My brother and them, they tore theirs up. I didn't tear mine up. I kept my harp. Then,

I learned how to blow that song 'Lay My Burden Down.' I learned how to blow that pretty good, and my daddy and my mama liked it. Then he bought me another harp, and I just kept on. They used to fry fish on Saturday night, you know, a quarter sandwich. That's when I started blowing with Lee Kizart. He used to come around where I was. Finally, I met Muddy Waters after I moved over near Clarksdale to Mattson, Mississippi. And he started coming over on Saturday night and pick guitar and things. Just out there in the yard with that acoustic guitar. He didn't have no electric."

After growing up in the Clarksdale area, Brock moved up to northwest Mississippi, closer to Memphis. That's where he first encountered Memphis Minnie at house parties and got to play with Howlin' Wolf for the first time in the late 1940s. The legendary Howlin' Wolf was living in the area at the time, though he hailed from the West Point, Mississippi area. "I came to Walls, Mississippi, and then I run into Howlin' Wolf in the back of a theater on Monday nights, so I started playing with him. I was working on 61 Highway, helping put in that gas line underground and build that dam all the way on 51 Highway. So anyway, I met Howlin' Wolf there and started setting up his instruments. Man, I'd do anything as long as I was around music. Didn't have to pay me. I just wanted to be there just that bad. He kind of liked the way I handled the instruments, so he started letting me set it up every Monday night. One night he was playing, and his girlfriend, Mattie, asked him to let me sing a number. He said, 'Any time my woman would rather hear somebody else than to hear me, it's time for you to go!' I lose my job over that, but he kept on being my friend.

"[Another time,] out there in the hills, they had a place where they hired bands to come and play in a little park area. We was out there one night, and you know how these guys in the country is. They kept on arguing and arguing, and they started shooting. So when all of the fireworks was over and everything, everybody's saying, 'Where's the Wolf? Where's Wolf at?' He say, 'I'm up here!' Everybody just looked up, and he come flying down that tree like a big ole coon. [Laughs.] I think Howlin' Wolf played one more song after that, and then he packed up and left.

"So, one thing led to another, and I started to do something on my own. I came to St. Louis and I got my own band. When I first got my own band, I was twenty-one or twenty-two—Big George & the Houserockers."

During the two days of interviews for this article, we ate lunch at Brock's favorite St. Louis soul food restaurant. Even it has a blues story.

"It was called the Moonlight [Lounge]," remembered Brock. "I think it was like fifty cents to get in if you had it. If you didn't have nothing but a

quarter, she'd still let 'em in. [Laughs.] Little Walter was blowing harmonica with Muddy Waters back in them days. One night, Little Walter got mad 'cause Muddy Waters called me up on the bandstand. He got mad and walked outside. Just went out there and sit down. We kept right on playing like he never left, and he got mad and came back and snatched his mic, 'Give me my mic back!' [Laughs.] 'Yes, sir.' Didn't matter to me nothing. I told him, 'I'm not trying to take your job.' It wasn't too long before I had my place [the first Club Caravan] down at Garrison and Franklin Streets. See, Muddy Waters was playing here first, and I used to come up here and be with him. And when I opened that joint down there at Garrison and Franklin, I got him to come down there with me. One time, he stayed at my place five nights straight."

"When I opened up my joint, I just did that for a living. It was a vacant building, and I went and asked the landlord, 'Could I rent that place?' He said, 'Yeah, but you got to fix it up.' It was in bad shape. We had to put a roof on it and everything. It was open Friday, Saturday and Sunday. I could seat one thousand people in my place. That's how big it was. Police Johnson used to own it. It was the Earlybird Lounge for quite a while. After Johnson closed it down, it got in bad shape. Then I come in there, and I opened it up. They wouldn't give me a license for but six months since so much had been happening there. It was a bad neighborhood. They used to call it the Bucket of Blood 'cause somebody would get hurt there every weekend. They told me, 'If you don't have a lot of problems in six months, we'll give you a license for a year. So after that, I got a license for a year and went on."

Acts who performed at Club Caravan include Muddy Waters, Howlin' Wolf, Jimmy Reed, Clarence "Gatemouth" Brown, Ike & Tina Turner, Shirley Brown, Denise LaSalle and Willie Foster as well as Brock with his own Houserockers band, which at various times featured Albert King, Big Bad Smitty or Riley Coatie on lead guitar.

When Wolf played Club Caravan, Brock recalled, "Hubert Sumlin was on lead guitar, and Charlie on drums, another boy was on bass, and Howlin' Wolf, he was on harmonica and guitar too. Wolf like to clown sometimes. He would be clowning with the women folk, you know. And making faces at them and stuff like that. Talking about, 'Your man can't do this, your man can't do that.' And all that kind of stuff. He was a big put on. That's mostly his style. Then, he'd get back and sit down. Start back to playing again. Sometimes he stand up and do that little shake at the women folks. And they liked it. Aw, yeah. Get 'em all good and warm. Especially when he'd lick his tongue out at them. [Laughs.] Yes, sir. He was playing that song one night,

'Walked All the Way from Mexico.' Aw man, he'd cut up sideways on that one. Folks stayed for it."

As much as he enjoyed Wolf's music and stage persona, Brock's main man was another fellow Mississippi native.

"Muddy Waters, oh he was way different from Howlin' Wolf. It just felt free. It felt more comfortable, and he treated you more better. He treated you with a smile, and he act like he always glad to see you. With Howlin' Wolf, it wasn't like that. He particular about how you act, particular what you say. He don't take no jokes or nothing. He strictly business like that. To me, Muddy Waters' performing was good with the music, but he didn't perform with his act like Howlin' Wolf. But far as the music, he was better. But he didn't get out there and do no monkey shine like Wolf did. If you wanted to hear some music, go hear Muddy. You want to see a show, go see Howlin' Wolf."

When asked about another Mississippi-born bluesman, Jimmy Reed, Brock rolls his eyes.

"Oh, my lord. Jimmy Reed was like a drunk. And he played songs and make all them sound the same. After you heard one or two of them, you done heard him do all his songs. You know, that kill your crowd, too. He stayed here at my house. And Muddy Waters stayed here with me. Muddy used to be glad to come home. Come in and eat with us. He let the boys stay at the hotel. Jimmy Reed used to sleep back in that other room. And in that bathroom back there, I had some big flowered paper on the wall. And he was in that bathroom so long, I knocked on the door and I said, 'You all right?' He said, 'Yeah, I'm all right.' He kept mumbling something. You know that song he put out about pictures of flowers on the wall? That's where he got it from—that bathroom. He made that song in there."

Sadly, Brock's first Club Caravan met a tragic end one fateful night. Besides being the club's owner and house-band leader, he was also the security.

"This guy was into it with his old lady. He came by my place, and she was in there. He wanted to jump on her in the place, and I said, 'No, you can't fight up in here.' He told me he could whoop his woman anywhere he see her. I said, 'No, you won't do it in here.' So, I put him out. When we was closing that night, he came back. He pushed the door open and started shooting. I turned around and just stood and looked at him. He shot about three or four more times and ran out the door. I didn't know my wife had got hit until after I come in the kitchen where she was laying on the floor. I ran back out, but he was gone."

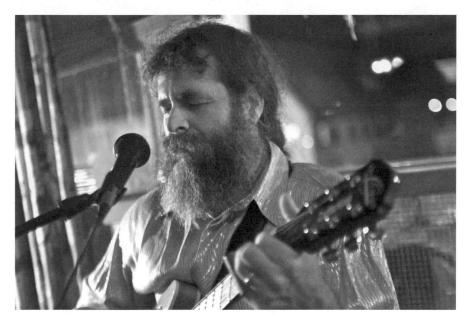

Bill Abel playing at Bobby J's (Natchez, Mississippi, 2009).

Brock's wife died, cradled in his arms as he awaited an ambulance on the steps of Club Caravan. He soon closed the club. "After that I didn't have no more confidence in the place. I didn't want it no more. It took a lot out of me. It really did."

After closing the first Club Caravan, Brock went back to playing other area clubs and began selling pig ears and Polish sausages out of a truck. He also sang through the truck's PA system to entertain his customers. In the mid-1970s, he opened another second Club Caravan but found the new location too small to turn a profit. He opened his final blues club in the 1980s called New Club Caravan; it finally closed in 1988. During our interview, we drove from one club location to another in St. Louis. As we sat in my van, staring at the spot of his final blues club, a bus pulled up at the intersection in front of the former venue. As it stopped, Brock said, "Like that bus going there? I had my cordless mic, and I used to go out there and sit on the bus and sing the blues. They wait on me to get through singing to the passengers. Then they pull off. The band and them, they be inside the club, and I be out there on the bus singing. I used to do that." [Laughs.]

BIBLIOGRAPHY

A List of Blues Sources and Influences

BOOKS

Calt, Stephen, and Gayle Wardlow. *King of the Delta Blues: The Life and Music of Charlie Patton*. Newton, NJ: Rock Chapel Press, 1988.

Charters, Samuel B. *The Country Blues*. New York: Da Capo Press, 1975.

Cheseborough, Steve. *Blues Traveling: The Holy Sites of Delta Blues*. Jackson: University Press of Mississippi, 2008.

Cobb, James C. *The Most Southern Place on Earth: The Mississippi Delta and the Roots of Regional Identity*. New York: Oxford University Press, 1992.

Cohn, David L. *Where I Was Born and Raised*. New York: Houghton Mifflin, 1948.

Davis, Francis. *The History of the Blues: The Roots, The Music, The People*. New York: Da Capo Press, 1995.

Dixon, Willie. *I Am the Blues: The Willie Dixon Story*. New York: Da Capo Press, 1990.

Edwards, David "Honeyboy." *The World Don't Owe Me Nothing: The Life and Times of Delta Bluesman Honeyboy Edwards*. Chicago, IL: Chicago Review Press, 2000.

Ferris, William. *Blues from the Delta: An Illustrated Documentary on the Music and Musicians of the Mississippi Delta*. New York: Anchor Press, 1978.

———. *Give My Poor Heart Ease: Voices of the Mississippi Blues*. Chapel Hill: University of North Carolina Press, 2009.

Garon, Paul. *The Devil's Son-in-Law: The Story of Peetie Wheatstraw and His Songs*. Chicago: Charles H. Kerr Publishing Company, 2003.

BIBLIOGRAPHY

Gordon, Robert. *Can't Be Satisfied: The Life and Times of Muddy Waters*. Boston: Little, Brown & Company, 2002.

Guralnick, Peter. *Searching for Robert Johnson*. New York: Dutton (Penguin Group), 1992.

Handy, W.C. *Father of the Blues: An Autobiography*. Edited by Arna Bontemps; foreword by Abbe Niles. New York: Macmillan, 1941.

Lomax, Alan. *Land Where Blues Began*. New York: New Press, 2002.

Merriam-Webster English Dictionary. Springfield, MA: Merriam-Webster, revised 2004.

Mitchell, George. *Blow My Blues Away*. Baton Rouge: Louisiana State University Press, 1971.

Murphy, Ken, and Scott Barretta. *Mississippi: State of Blues*. Bay St. Louis, MS: Proteus/Ken Murphy Publishing, 2010.

Nicholson, Robert. *Mississippi: The Blues Today*. New York: Da Capo Press, 1999.

Oakley, Giles. *The Devil's Music: The History of the Blues*. New York: Da Capo Press, 1997.

Otto, John Solomon. *The Final Frontiers, 1880–1930: Settling the Southern Bottomlands*. Westport, CT: Greenwood Press, 1999.

Palmer, Robert. *Deep Blues: A Musical and Cultural History of the Mississippi Delta*. New York: Penguin Books, 1981.

Pearson, Barry Lee, and Bill McCulloch. *Robert Johnson: Lost and Found*. Champaign: University of Illinois Press, 2008.

Rowe, Mike. *Chicago Blues: The City and the Music*. New York: Da Capo, 1975.

Turner, Ike. *Takin' Back My Name: The Confessions of Ike Turner*. London: Virgin Books, 1999.

Van der Tuuk, Alex. *Paramount's Rise and Fall*. Littleton: Mainspring Press LLC, 2003.

Wardlow, Gayle Dean. *Chasin' that Devil Music: Searching for the Blues*. San Francisco, CA: Miller Freeman Books, 1998.

Wyman, Bill, and Richard Havers. *Bill Wyman's Blues Odyssey*. London; New York: DK Publishing, 2001.

PUBLICATIONS

"Masthead/Mission Statement." *Living Blues*, http://www.livingblues.com.

"Notes on Negro Music." *Journal of American Folklore* 16, no. 62 (July–September 1903): 148–52.

Stolle, Roger. Cat Head's Delta. *King Biscuit Time* (various issues), http://www.kingbiscuittime.com.

———. Down in the Delta. *Blues Revue* (various issues), http://www.bluesrevue.com.

———. "T-Model Ford." *Delta Magazine*, http://www.deltamagazine.com.

"Touring the American Egypt." *Reykjavik Grapevine*, October 2, 2006. http://www.grapevine.is.

"Unintended Consequences of Biofuels Production." *U.S. Geological Survey*, 2007, http://www.usgs.gov.

OTHER

"Fatal Flood: A Story of Greed, Power and Race." *American Experience*. PBS, 1999–2000. http://www.pbs.org.

Hard Times: The Blues Story of Big George Brock. DVD. Clarksdale, MS: Cat Head Presents, 2006. http://www.cathead.biz.

Jefferson, Wesley. "Meet Me in the Cotton Field." *Meet Me in the Cotton Field*. CD. St. Louis, MO: Broke & Hungry Records, 2007. http://www.brokeandhungryrecords.com.

M for Mississippi: A Road Trip through the Birthplace of the Blues. DVD. Clarksdale, MS: M for Mississippi/Three Forks Music, 2008. http://www.mformississippi.com.

Index

About the Author and Photographer

Roger Stolle

Roger Stolle owns Cat Head Delta Blues & Folk Art, a blues store in Clarksdale, Mississippi, as well as his own music and tourism marketing service. He is a *Blues Revue* magazine columnist, WROX radio deejay, XM/Sirius radio correspondent, Ground Zero Blues Club music coordinator and Juke Joint Festival cofounder. Through his Cat Head Presents record label, Stolle has produced several critically acclaimed blues CDs/DVDs; he coproduced the award-winning film *M for Mississippi: A Road Trip through the Birthplace of the Blues*. *Hidden History of Mississippi Blues* is his first book. Stolle's Cat Head store has been called "one of the 17 coolest record stores in America" (*Paste* magazine), is included in the book *1,000 Places to See Before You Die* (Workman Publishing) and received a Keeping the Blues Alive Award (Blues Foundation). He was educated at the University of Cincinnati and worked for thirteen years in the advertising and marketing world prior to entering the music business. http://www.cathead.biz.

Lou Bopp

Lou Bopp is an award-winning commercial location photographer. He came to the blues as a music fan and has photographed a majority of the

most significant Mississippi blues musicians in recent years. In the blues music realm, Bopp has photographed everyone from James "T-Model" Ford to "Big" George Brock; he has gone from juke joint to house party, from pool hall to living room in search of his subjects. The human experience intrigues and fascinates Bopp, and his goal is to capture images that reflect the authenticity and meaning of this experience. Bopp has traveled the world on assignment for clients such as Time Warner, Deutsche Bank, McCann-Erickson, Amex, *Sports Illustrated*, Y&R and many more. His subjects range from celebrities to CEOs, musicians to technicians. His work has taken him from the floor of the NYSE to the top of the Empire State Building, from the renowned sands of Iwo Jima to the legendary "crossroads" of Clarksdale, Mississippi. He once shot on three continents on a single day. Bopp is based in New York City, St. Louis and, at times, the Mississippi Delta. http://www.loubopp.com.